# Constable's Skies

PAINTINGS AND SKETCHES BY JOHN CONSTABLE

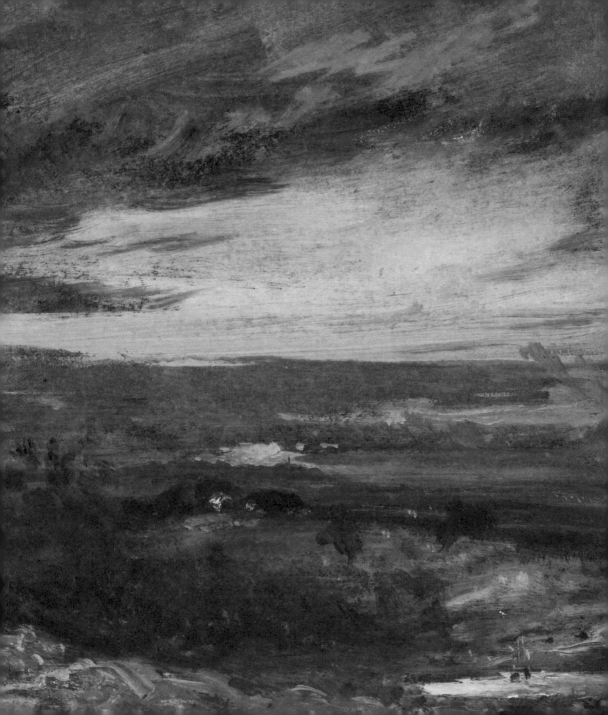

# Constable's Skies

### PAINTINGS AND SKETCHES BY JOHN CONSTABLE

Mark Evans

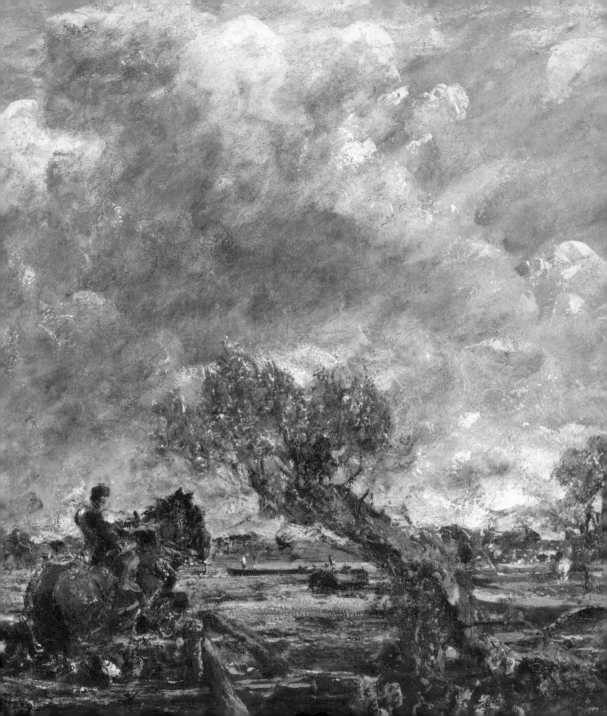

# Contents

# Preface

Fig. 1 Detail from *Hampstead Heath (The Vale of Health)*, *c.*1822 (p. 93)

Constable's mastery of landscape is inseparable from his supreme accomplishment as a painter of the sky, for as he observed to his friend John Fisher: 'It will be difficult to name a class of landscape in which the sky is not the key note, the standard of scale, and the chief organ of sentiment....The sky is the source of light in nature and governs everything.' In 1821–2 the artist went on a 'skying' campaign, making remarkable oil sketches of cloudy skies which he annotated with the time of day and prevailing weather conditions.

Constable scorned to put a price on such works, which he considered raw material for exhibition paintings. During the era of Impressionism his sketches were recognized as 'faithful and brilliant' and by the centenary of his death in 1937 they were even revered as harbingers of Abstraction and Surrealism.

It has been argued that Constable was inspired by the cloud classification of 'the father of meteorology', Luke Howard (1772–1864). A scientific appraisal of his depictions of the sky appeared in 1999, followed by exhibitions on the subject in 2000 and 2004. Constable's skies continue to inspire artists, such as the American painter Byron Kim (b. 1961) and the Canadian photographer Scott McFarland (b. 1975).

This survey of works in the Victoria and Albert Museum and other collections uses Constable's own notes and contemporary weather diaries to show how between 1802 and 1836 his depictions of the sky attained a hitherto unequalled truth to nature.

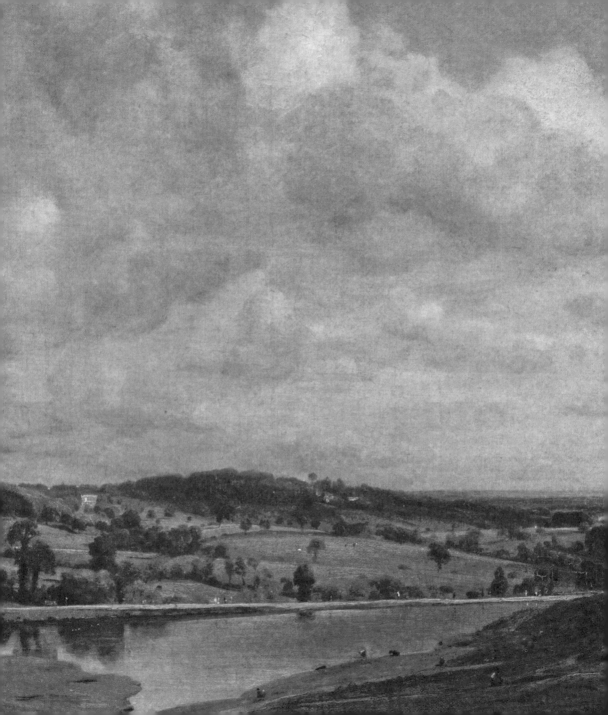

# Introduction
## 'The natural history of the skies above'

John Constable (1776–1837) is best known today as the painter who transformed the art of landscape painting by combining the lessons of the old masters with his own profound observations of nature. This resulted in some of the most familiar and best loved paintings of the English countryside.

He was also a peerless painter of the weather, whose depictions of the sky determined the remarkably expressive mood of his great landscapes such as *The Hay Wain* (1821) and *Salisbury Cathedral from the Meadows* (1831). These were based upon many vibrant and spontaneous oil sketches which he painted mainly outdoors, direct from nature. The most spectacular were made on Hampstead Heath in 1821–2 and at Brighton in 1824. Some of the most radical are pure skyscapes in which the clouds appear alone.

Constable's interest in accurately depicting the sky coincided with an expansion of popular interest in science and the birth of modern meteorology, a subject he followed closely.

## Constable and the science of meteorology

On Wednesday 15 October 1823, Constable was hurrying to finish a reduced replica of his *Salisbury Cathedral from the Bishop's Grounds* (46) as a present to 'greet & surprize' the newly wed daughter of his patron the Bishop of Salisbury on her arrival in London.[1] He would therefore have been too busy to attend, had he known of it, the inaugural meeting of the Meteorological Society of London, held that evening at the London Coffee-house on Ludgate Hill.[2]

8

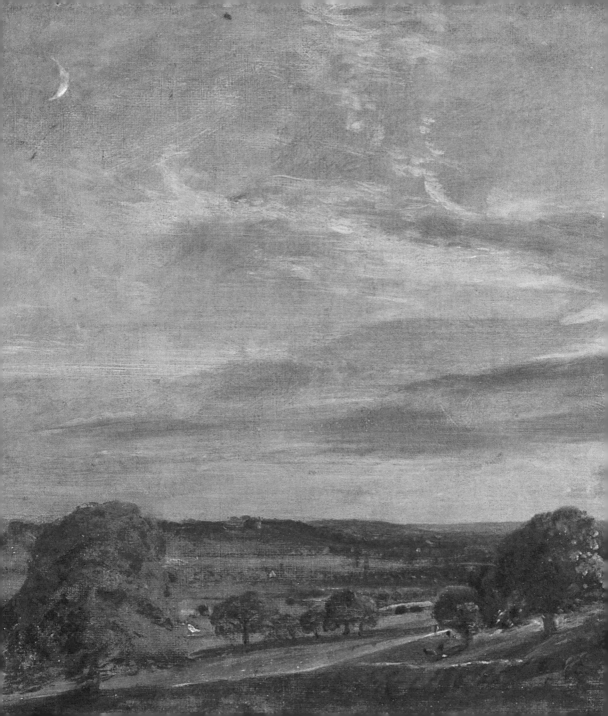

The case for such a society had been put by James Tatem in a letter to *The Monthly Magazine* on 1 April 1823, and its launch announced that September. Membership was open to all with 'a desire to promote the science of Meteorology', subject to an annual subscription of two guineas, payable in advance. Its founders included the chemist Luke Howard (1772–1864) and the astronomer and naturalist Thomas Forster (1789–1860). Howard was dubbed 'the father of meteorology' for his systematic recording of the weather, first published in 1818 in *The Climate of London*, and his seminal classification of clouds, the basis of that still used today.[3] His weather tables inspired Tatem, also a founder member, to compile similar data at High Wycombe which was published from 1825, and Charles Henry Adams, headmaster of the Latymer School at Edmonton, to make his own local record, which appeared during the 1830s.[4] Forster's *Researches about Atmospheric Phaenomena* (1813) provided the principal introduction to this subject until the appearance in 1837 of Howard's *Seven Lectures on Meteorology*.[5]

Constable's knowledge of meteorology was well advanced by this time. A countryman and the son of a miller, he had been brought up since childhood with a profound empirical understanding of the sky and the weather. This is strikingly apparent in his penetrating analysis of a landscape (**66**) by the Dutch master Jacob van Ruisdael (1628/9–1682), provided in a lecture on 9 June 1836:

> The picture represents an approaching thaw…there are two windmills…one has the sails furled, and is turned in the position from which the wind blew when the mill left off work; the other has the canvas on the poles, and is turned another way, which indicates a change in the wind. The clouds are opening in…the south…and this change will produce a thaw before the morning. The concurrence…shows that Ruysdael *understood* what he was painting.[6]

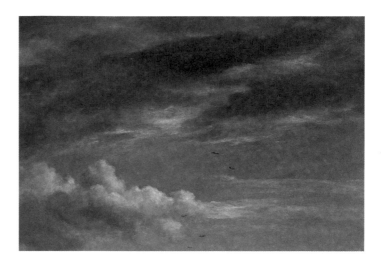

However, Constable also supplemented his own observations and experience with extensive reading and study. He owned a copy of the second edition of Thomas Forster's book (1815), which he annotated extensively. His notes reveal that he was particularly interested in Howard's classification, the forms of clouds and their effect on the illumination of the landscape, and had enough knowledge of meteorology to identify ambiguities in Howard's system and to dispute passages in Forster's book.[7] In a letter he sent to a friend in December 1836, he offers help 'If you want any thing more about atmosphere' and cautions that Forster was 'far from right', while conceding that his study remained 'the best book' because it had 'the merit of breaking much ground'.[8] Constable added that he planned to assemble his own 'observations on clouds and skies', then still 'on scraps and bits of paper…to form a lecture, which I shall probably deliver at Hampstead next Summer' – an intention forestalled by his unexpected death during the night of 31 March 1837.

This interest in meteorology provides substance to Constable's proud and often quoted boast in conclusion to a public lecture: 'Painting is a science and should be pursued as an inquiry into the laws of nature.

INTRODUCTION

Why, then, may not a landscape be considered as a branch of natural philosophy, of which pictures are but experiments?'[9]

As his remark suggests, during Constable's lifetime experimental science was transforming traditional natural philosophy.[10] The growing popular fascination with science – memorably portrayed as early as 1768 by Joseph Wright of Derby (1734–1797) in his celebrated painting of *An Experiment on a Bird in the Air Pump* – was catered for by public lectures, such as those on chemistry given at Liverpool in 1795 by the physician Thomas Garnett (1766–1802). It was also evident in the foundation of learned societies, including the Linnean Society in 1788 and the Zoological Society in 1826, as well as the Meteorological Society.[11]

Constable's interest in science is clear from his reading, which extended beyond the books one might expect to find in an artist's library.[12] His quest 'for a natural painture' drew his attention to studies of zoology and botany by Georges Cuvier (1769–1832), Henry Phillips (1779–1840), James Rennie (1787–1867) and Gilbert White (1720–1793).[13] He also owned a copy of Thomas Garnett's *Outlines of a Course of Lectures on Chemistry* (1797) and the treatise *Chromatography* (1835) by his friend George Field (1777–1854), suggesting some acquaintance with chemistry.[14]

Constable would have been familiar with William Paley's contention in his widely read *Natural Theology* (1802) that 'the sky, the world, could only be *illuminated*, as it is illuminated, by the light of the sun being from all sides, and in every direction, reflected to the eye, by particles, as numerous, as thickly scattered, and as widely diffused, as are those of the air'.[15] He could also have read Garnett's characterization of the atmosphere as 'a thin, transparent, invisible fluid' comprising oxygen and nitrogen plus 'some other gases or substances capable of being dissolved or suspended'.[16]

Light and shade had been a major concern of artists since the time of Leonardo da Vinci, whose *Treatise on Painting* provided Constable with 'great pleasure in reading' in 1796, still scarcely out of his teens.[17] His other textbooks included William Hogarth's *The Analysis of Beauty* (1753), which observed 'that the pleasure arising from composition, as in

a fine landskip, &c. is chiefly owing to the dispositions and assemblages of light and shades'.[18] In 1796 the painter John Cranch (1751–1821) also recommended him to the writings of the Abbé Jean-Baptiste Dubos (1748), who remarked that the differing atmospheric conditions of Italy and Flanders were 'observable in the painted skies of Titian and Rubens'.[19]

Field's *Chromatography* interpreted light as a *material* presence, caused by 'the concurrence or conjunction of two aethereal, electrical or elementary substances', one 'the active principle of light…contingent if not identical with the oxygen of the chemist' and the other 'the principle of shade or darkness', which its author believed to be hydrogen.[20] His perception of light has been likened to Constable's artistic preoccupation with the fall of light and shade outdoors, which he aptly termed 'the Chiar' Oscuro of Nature'. As he explained: 'Chiaroscuro…may be defined as that power which creates space; we find it everywhere and at all times in nature; opposition, union, light, shade, reflection, and refraction, all contribute to it.'[21]

## Constable's early skies, 1802–18

When Constable exhibited his first painting at the Royal Academy in 1802, the senior Academician Joseph Farington (1747–1821) expressed the view that 'the picture has a great deal of merit but is rather too cold' and advised his protégé 'to Study nature and *particular* art less'.[22] The young painter seems to have accepted this criticism, but rejected the advice, for soon after he announced to a friend his intention to 'make some laborious studies from nature…to get a pure and unaffected representation…with respect to colour particularly'.[23] Nevertheless, the oil sketch of *Dedham Vale: Evening*, painted in July 1802 (1), has a bland sky enlivened by gentle clouds and suffused by the setting sun, features reminiscent of the much admired Italianate landscapes of Richard Wilson (1713?–1782).[24] That September Constable painted a view of the Stour estuary (2), whose composition is based on a landscape of *Hagar and the Angel* by Claude Lorrain (*c.*1600–1682), a favourite treasure of Constable's mentor Sir George Beaumont.[25] Despite Constable's observation of local scenery,

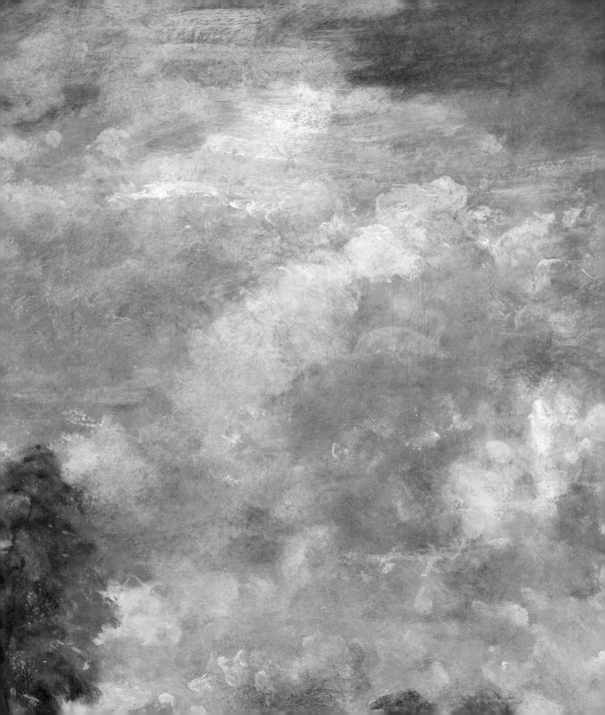

the sky in his painting remains formulaic, with distant flat clouds bearing little relationship to the fall of light in the scene.[26]

Around this time he probably received the advice from the President of the Royal Academy, Benjamin West (1738–1820), which he repeated years later to his own protégé and posthumous biographer, C.R. Leslie (1794–1859):

> Always remember, sir, that light and shadow *never stand still....* In your skies, for instance, always aim at *brightness*, although there are states in the atmosphere in which the sky itself is not bright. I do not mean that you are not to paint solemn or lowering skies, but even in the darkest effects there should be brightness. Your darks should look like the darks of silver, not of lead or of slate.[27]

Constable's contemporary Thomas Girtin (1775–1802) would reputedly 'expose himself to all weathers, sitting out for hours in the rain to observe the effects of storms and clouds upon the atmosphere' to capture dramatic and naturalistic effects in his watercolours, which were much admired; his early death was widely mourned.[28] A keen collector, Beaumont recommended his works 'as examples of great breadth and truth'.[29] In the autumn of 1806, Constable made his only sketching trip to the Lake District, a region celebrated for its picturesque scenery. The weather was mostly rainy, and although Leslie later reported that he found 'the solitude of the mountains oppressed his spirits', the artist produced a series of watercolours which reproduce with verve the rapidly changing effects of light and atmosphere (4).[30] Working in this unfamiliar scenery, he began to annotate his sketches with information such as the date, location and weather conditions. This was a practice he would resume in 1820 (17) and that later became habitual.

In 1810 Constable resumed outdoor sketching in oils, a practice then most unusual in England. Although he had lived in London since 1799, he considered East Bergholt his home until his marriage in 1816, and usually spent much of the summer and early autumn in its familiar

Fig. 4 Detail from *Full-scale Study for 'The Hay Wain'*, 1820–1 (p. 56)

surroundings. Constable adored the placid arcadian landscapes of Claude, but was profoundly stirred by 'the freshness and dewy light, the joyous and animated character' of Peter Paul Rubens (1577–1640), who 'delighted in phenomena; – rainbows upon a stormy sky – bursts of sunshine – moon-light, – meteors – and impetuous torrents mingling their sound with wind and waves.'[31]

It was perhaps in emulation of the Flemish master that in 1810–12 he painted a number of vivid and highly coloured oil sketches which transfigure the scenery of the Stour valley with startling atmospheric effects (6, 8, 10, 11, 12). Seeing a large Rubens, *Landscape with Market People*, at the British Institution in 1819, he adapted its composition in an oil sketch (15), reverting to a practice used in 1802 (2).[32] This and other sketches (13, 14, 61) furnished compositions for exhibition paintings (55) and mezzotints (62). Constable also essayed cabinet pictures which were small enough to be painted at least partly out of doors (9, 45, 59).

Fig. 5 Detail from *Hampstead Heath: Branch Hill Pond*, 1828 (p. 107)

## Hampstead and the sky studies, 1819–24

On account of the poor health of Constable's wife, Maria, the couple rented accommodation at Hampstead from August 1819, and settled there in 1827. High above the city, its elevated location and relatively smoke-free environment offered an ideal location to view the sky, as had been discovered over a century earlier by the Dutch master Willem van de Velde the younger (1633–1707).[33] At the British Institution on 13 July 1819 Constable studied two of van de Velde's maritime paintings, and he could have read in his copy of William Gilpin's *On Landscape Painting: A Poem* (1792) how his Dutch predecessor made cloud studies from a boat in the Thames, in black and white chalks on blue paper.[34] It can be no accident that Constable used this very technique in his earliest datable pure sky studies,[35] one of which is inscribed 9 July 1819, just a few weeks before his move to Hampstead. From mid-October 1820 he began more systematically to sketch the skies in oils (17, 18).

This new departure may have contributed to his abrupt decision, a few weeks later, to begin *The Hay Wain* (19) as his principal submission to

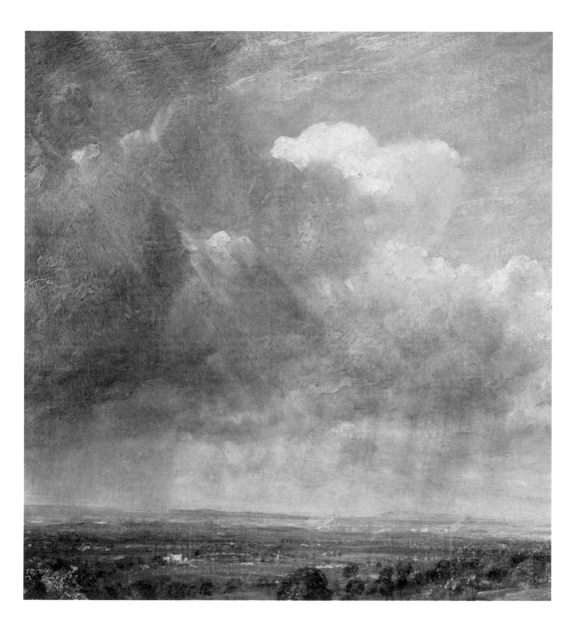

INTRODUCTION

Fig. 6 Detail from *Trees at Hampstead: the Path to Church*, c.1821/2 (p. 79)

the Royal Academy in 1821. The meteorologist John Thornes describes this celebrated work as:

> the first of his finished pictures to achieve the harmony that Constable wanted in his sky…to bind the landscape and the noon sky together, to achieve consistent light and convincing cloud form and perspective. Thus *The Hay Wain* represents a significant watershed in Constable's sky painting. Constable's skies during and after 1821 are demonstrably superior to all his skies before 1821.[36]

That these qualities were recognized by some visitors to the Academy is suggested by the appreciative review of Robert Hunt:

> *Landscape-Noon* – is a picture by Mr. CONSTABLE, which we think approaches nearer to the actual look of rural nature than any modern landscape whatever…for what an open air and fresh and leafy look it has with its cottage and

foreground so brightly and yet so modestly contrasting their reddish hue with the green and blue and yellow tints of the trees, fields, and sky – a sky which for noble volume of cloud and clear light we have never at any time seen exceeded except by Nature.[37]

However, 'those scattered and glittering lights that pervade every part' disconcerted one critic, while another felt 'His dark clouds impart too much of their sombre hue to his trees'. [38]

This mixed response to the lighting effects of *The Hay Wain* may have decided Constable, the following July, to embark on the systematic oil sketching of the sky over Hampstead, which he described to his close friend Archdeacon John Fisher as a 'more particular and general study than I have ever done in one summer'.[39] This reveals a shift of interest from the dramatic sunsets which had long beguiled him (17, 18, 24, 30–31) to amorphous configurations of clouds, initially depicted beyond a screen of trees (20–23, 25, 27) or above a strip of landscape (26, 28).

Warming to his subject, Constable expounded his views on painting skies:

I have done a good deal of skying…That landscape painter who does not make his skies a very material part of his composition – neglects to avail himself of one of his greatest aids. Sir Joshua Reynolds speaking of the 'Landscape' of Titian & Salvator & Claude – says *'Even their skies seem to sympathise with the subject'*. I have often been advised to consider my Sky – as a *'White Sheet drawn behind the Objects'*. Certainly if the Sky is *obtrusive* – (as mine are) it is bad, but if they are *evaded* (as mine are not) it is worse, they must and always shall with me make an effectual part of the composition. It will be difficult to name a class of Landscape, in which the sky is not the *'key note'*, the *standard of 'Scale'*, and the chief *'Organ of sentiment'*. You may conceive then what a *'white sheet'* woud do for me… The sky is the *'source of light'* in nature – and governs every

thing. Even our common observations on the weather of every day, are suggested by them but it does not occur to us. Their difficulty in painting both as to composition and execution is very great, because with all their brilliancy and consequence, they ought not to come forward or be hardly thought about in a picture...But these remarks do not apply to phenomenon – or what the painters call accidental Effects of Sky – because they always attract particularly.[40]

Simply put, Constable sought to make the sky a formative participant in his compositions without itself becoming a primary focus of attention.

When the weather allowed, he continued to make sky studies into the winter of 1821 (29), and after submitting his Academy exhibits the following spring, resumed outdoor sketching on Hampstead Heath during the summer of 1822. Increasingly, he painted views in sequence to show the development of atmospheric effects (36–37) as well as the metamorphosis of pure cloudscapes just above the horizon (39–42) and higher in the sky (38, 43), sometimes on sheets as large as cabinet paintings.[41] Among the most timeless and arresting images of nature ever made, these often include notes of the date, time and weather, analogous to the more detailed meteorological tables in Howard's *The Climate of London*. An inscription which appears to read *cirrus* on the back of Constable's smallest and most exquisite cloud study, undated but probably of this period (33), suggests familiarity with Howard's terminology.[42] Consummate skill in depicting the sky is evident in *Hampstead Heath (The Vale of Health)* (45), which a modern commentator admired for 'Probably the most subtly illusionistic sky found in his entire *oeuvres*...the cloud forms approximate the look of actual clouds to a degree unequalled elsewhere in art'.[43]

Constable's concern that his depictions of the sky seemed 'obtrusive' was shared by Bishop John Fisher (1748–1825), uncle and namesake of the artist's friend. After his patron was shown a preparatory sketch for *Salisbury Cathedral from the Bishop's Grounds* (46) Archdeacon Fisher had to explain to Constable: 'The Bishop likes your picture "all but the

clouds" he says. He likes "a clear blue sky".[44] The painting was politely received at the Academy in 1823, but the bishop continued to object: '[If] Constable would but leave out his black clouds! Clouds are only black when it is going to rain. In fine weather the sky is blue.'[45] Constable therefore painted a replica with a clear sky, but this was still unfinished on his patron's death two years later.

That summer and early autumn Constable painted a handful of oil studies mostly of sunsets (47, 48). During his stay late in 1823 at Corleorton Hall in Leicestershire – the home of his mentor Sir George Beaumont – he briefly interrupted his careful copying of the paintings by Claude in Beaumont's collection to make rapid pencil and ink memoranda from the stylized engravings of clouds in a copy of Alexander Cozens's *A New Method of Assisting in the Invention in the Composition of Landscape* (*c*.1785).[46]

## Brighton and Salisbury, 1824–8

To improve Maria Constable's increasingly precarious health, the artist and his family stayed at Brighton between July and October 1824, and returned there in 1825–6 and 1828. He found the fashionable resort and its environs utterly distasteful (52), complaining to Fisher: 'The magnificence of the sea, and its…everlasting voice, is drowned in the din & lost in the tumult…and the beach is only Piccadilly…by the seaside.'[47] Yet in these maritime surroundings Constable painted a series of spectacular oil sketches, which capture with remarkable spontaneity what he later praised as the 'continual change and ever-varying aspect' of the seaside, variously on bright, windy days (50), in sunny weather (51), during violent squalls (49, 53) and bathed by sumptuous sunsets (56).[48] After he lent Fisher a number of the studies, his friend appreciatively characterized them as 'full of vigour, & nature, fresh, original, warm from observation of nature, hasty, unpolished, untouched afterwards'.[49]

While planning a large 'set piece', *The Leaping Horse*, in November 1824, Constable remarked that 'change of weather & effect will afford variety in landscape'.[50] He took considerable trouble over the full-size

sketch of this composition (54), reworking it with brush and palette knife to establish a contrast between light and shade, while darkening the left-hand corner of the sky and the originally bright highlights in the clouds. He later lightened the sky overall in the exhibition painting, his principal submission in 1825, which he described as 'lively – & soothing – calm and exhilarating. Fresh – & blowing'.[51]

Constable's *Hampstead Heath: Branch Hill Pond* (55) was shown at the Academy in 1828; it is most likely the unidentified *Landscape* called a 'rich and varied piece of colouring' by the reviewer who summarized its weather effects: 'A shower has apparently just passed over, and a few flitting clouds throw their flickering light and shades over the country. The gleaming water in the distance is inimitable.'[52] The composition proved popular, and another version[53] was acquired by Constable's neighbour, the comedian Jack Bannister (1760–1836), who had enthused to the artist: 'he breathes my pictures, they are more than fresh, they are exhilarating'.[54]

Fatally ill with tuberculosis, Maria Constable declined rapidly and died on 23 November 1828. On 10 February her grieving widower received some consolation from his election as a Royal Academician, and that July spent three weeks with Archdeacon Fisher at Salisbury.[55] From Leadenhall, Fisher's residence in the cathedral close, Constable painted robust oil sketches of blustery weather above Harnham Ridge (57, 58). He visited the long abandoned site of Old Sarum to make a drawing which he later worked up as an oil sketch and a major watercolour (60, 70). He also began the painting *Watermeadows at Salisbury* (59), which he submitted to the following year's exhibition, only to withdraw it in a rage when it was thoughtlessly criticized by fellow Academicians.[56] It was during this productive interlude that the artist and the archdeacon first discussed a new 'six foot' canvas they called the 'Church under a cloud', which would ultimately become his late masterpiece, *Salisbury Cathedral from the Meadows* (64).[57]

Fig. 7 Detail from *Watermeadows at Salisbury*, 1829 (p. 112)

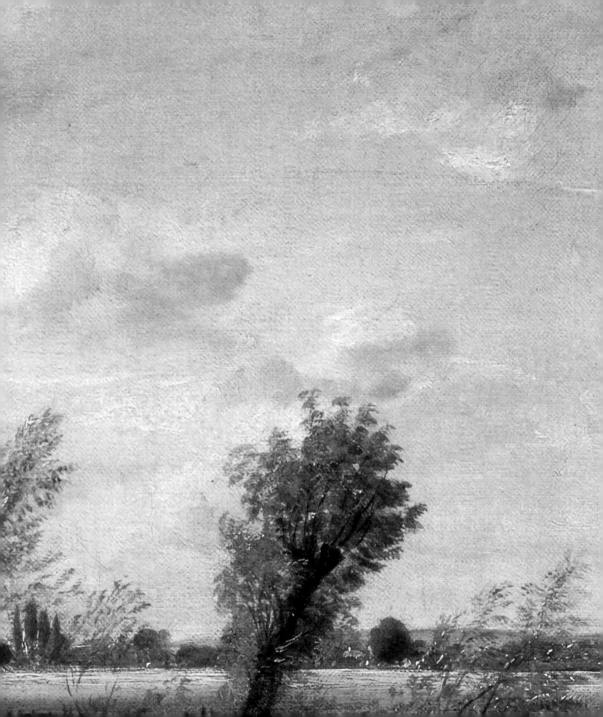

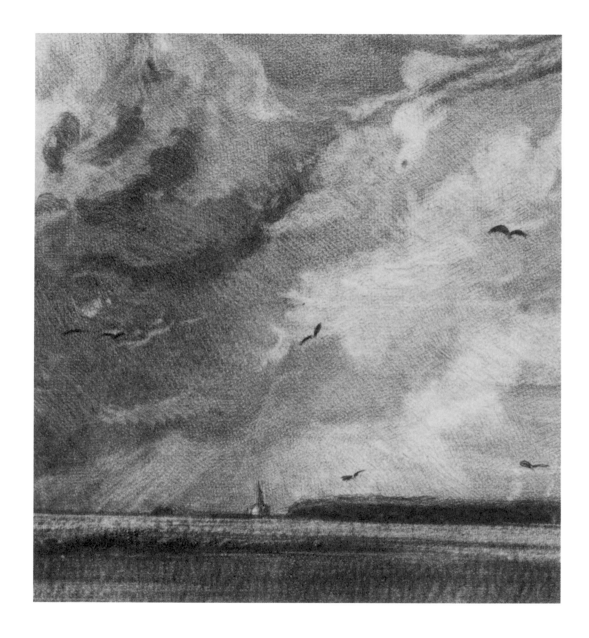

INTRODUCTION

## Experiments with reproduction, 1829–33

Constable and Fisher had for some time pondered over means of reproducing the artist's work. His friend first suggested the recently developed technique of lithography, venturing that he could have a pencil sketch 'done on stone as an experiment'. Fisher himself remained sceptical that it was possible to adequately reproduce the artist's paintings, remarking some years later: 'There is in your pictures too much evanescent effect & general tone to be expressed by black & white. Your charm is colour & the cool tint of English daylight.'[58]

Nonetheless, from 1829 Constable collaborated with the engraver David Lucas (1802–1881) to produce a series of his landscapes in mezzotint – a grainy technique offering a rich range of tones to express the atmospheric effects in which he excelled.[59] Constable may well have considered mezzotint engraving 'a pictorial equivalent for the particle-saturated atmosphere' – a reflection of the theory espoused by his friend George Field and others that light and air had a material presence.[60] Financed and supervised by the artist, *Various Subjects of Landscape, Characteristic of English Scenery* appeared in instalments during 1830–2. The second edition of 1833 (**62**) bore the significant subtitle *Principally intended to mark the Phenomena of the Chiar' Oscuro of Nature.* Constable's accompanying text was the most extensive commentary on his art published during his lifetime. It is replete with insights on atmospheric effects such as 'the lanes of the clouds…almost uniformly in shadow, receiving only a reflected light from the clear blue sky immediately above' or 'a Rainbow can never appear foreshortened, or be seen… through any intervening cloud, however small or thin, as the reflected rays are dispersed by it'.[61] *Various Subjects of Landscape* was much admired by George Field, who after the artist's death collaborated with Lucas on a proposed second series of mezzotints (which was never published).[62]

## Watercolour and last years, 1830–7

Preoccupied with *Various Subjects of Landscape*, and his duties as a newly elected Academician serving on the Council of the Royal Academy,

Constable abandoned outdoor sketching in oils in 1830. He reverted to the more spontaneous medium of watercolour, which he used in expressive sky studies (**63, 65, 68**) as well as more objective records of places visited (**72**). A major project was his final great 'six-footer', *Salisbury Cathedral from the Meadows*. The work was first exhibited in 1831 accompanied by a description of a storm from James Thomson's poem *The Seasons* (1727), which begins:

> As from the face of heaven the scatter'd clouds
> Tumultuous rove, th'interminable sky
> Sublimer swells, and o'er the world expands
> A purer azure. [63]

In view of Constable's expert knowledge of atmospheric effects shown in his watercolour of *London from Hampstead, with a Double Rainbow* (**65**), it is odd that the rainbow in *Salisbury Cathedral from the Meadows* does not correspond to nature – such phenomena are only visible when the sun is behind an observer, and in this work the source of illumination is at the top right. The rainbow alights on Leadenhall, John Fisher's home. However, there may be an explanation for this. After its initial display, Constable continued to revise the painting, and John Thornes has recently shown, with the aid of solar geometry, that at the time of the archdeacon's death on 25 August 1832 there could have been a rainbow where Constable depicts it.[64] This suggests that he added the rainbow – a traditional biblical symbol of Salvation – later, to commemorate his friend. Although the painting received discouraging reviews, in 1834 Lucas began a mezzotint of its composition (**73**), his largest after Constable, which was published only a few days before the artist's death.

*Salisbury Cathedral from the Meadows* is clearly indebted to Jacob van Ruisdael's magnificent funereal composition *The Jewish Cemetery*, and in a letter to C.R. Leslie Constable likened the desolate subject-matter of his copy after Ruisdael's *Winter* (**66**) to his sadness at Fisher's death.[65] Its bleak mood contrasts with the lyrical noon-day air of *The Cottage*

*in a Cornfield* (67), painted shortly after, but itself a replica of an earlier work, painted in 1817.[66] The earlier version has a rudimentary sky which contrasts markedly with the dramatic and assured handling of the clouds in the later painting, exhibited in 1833.[67] With typical finesse, Constable depicted the corn as remaining green where it is overshadowed by the cottage, while the rest of the field is already ripe.

During his last years, Constable was principally involved with his artistic testament, which he expounded through the exemplary mezzotints in *Various Subjects of Landscape* and the lectures on landscape painting he gave at Hampstead in 1833, Worcester in 1835, and the Royal Institution in 1836. He had hoped to continue with his 'observations on clouds and skies' at Hampstead during the summer of 1837. Several major compositions, notably *Hadleigh Castle* of 1829,[68] *Old Sarum* (70) and *Stonehenge* (74), have distinctly monumental and retrospective subjects. Others, including, it would appear, *Salisbury Cathedral from the Meadows* (64) and *The Cenotaph*,[69] exhibited in 1836 and dedicated to the memory of Sir Joshua Reynolds and Sir George Beaumont, are explicitly commemorative. All depict overcast or stormy weather, sometimes mitigated by a rainbow.

Graham Reynolds proposed that Constable's increased use of watercolour contributed to what he aptly termed the 'lightness and flicker of accents' characteristic of the artist's late work, in which 'the sky has a curious transparency which is almost flimsiness'.[70] Such images seem to move beyond the representational towards the expressive and emotive (69, 71, 75). Constable's final skies show how well he applied the advice of Benjamin West 'that light and shadow *never stand still*' and took to heart Joshua Reynolds's insight into the landscapes of Titian (*c.*1485–1576), Salvator Rosa (1615–1673) and Claude Lorrain: 'Even their skies seem to sympathise with the subject.'

# Plates

This sketch has pin holes
where it was attached to a
rigid support for painting
out of doors. It depicts the
view from East Bergholt
towards Stoke-by-Nayland,
but its mellow tonalities
are reminiscent of earlier
classical landscapes.

1. *Dedham Vale: Evening*, 1802
Oil on canvas, later lined,
31.8 × 43.2 cm (12 1/2 × 17 in.)
Inscribed on stretcher: *July
1802, and Towards Evening
painted by J Constable RA 1802*
Victoria and Albert Museum, London
(V&A: 587–1888)

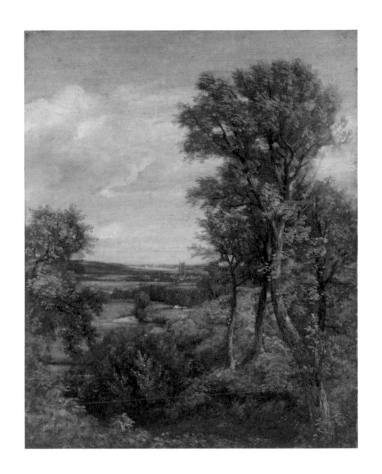

2. *Dedham Vale from the Coombs*, 1802
Oil on canvas, later lined,
43.5 × 34.4 cm (17⅛ × 13½ in.)
Inscribed on stretcher: *Sep 1802*
*John…Isabel Constable*
Victoria and Albert Museum, London
(V&A: 124–1888)

Constable knew this local scenery intimately, but his composition is based on a landscape of *Hagar and the Angel* by Claude Lorrain. The artist painted several variants of this subject in 1805–17 and a large upright version, exhibited in 1828.

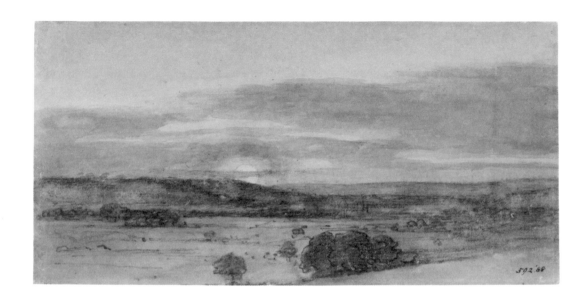

3. *Dedham Vale from East*
*Bergholt: Sunset,* 1805
Watercolour and pencil,
10.1 × 20.2 cm (4 × 8 in.)
Inscribed by the artist on
the back: *E. Bergholt; J.C.*
Victoria and Albert Museum, London
(V&A: 592–1888)

Constable showed a renewed interest in watercolours in 1805–6.
This is one of a group of works painted in greyish tones over
underdrawing. Their solemn character recalls the watercolours
of Thomas Girtin, which Constable sometimes copied.

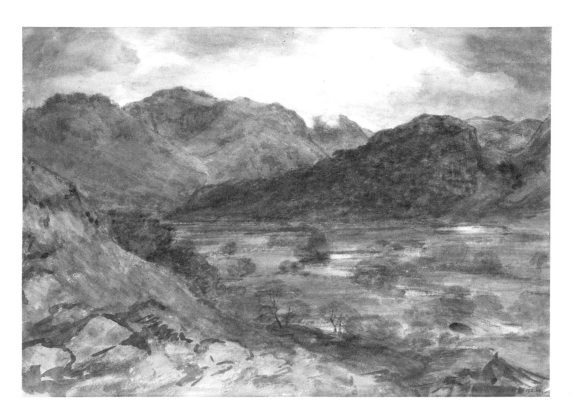

4. *View in Borrowdale*, 1806
Watercolour and pencil,
24.3 × 34.6 cm (9½ × 13⅝ in.)
Inscribed by the artist on the back:
*25 Sepr. 1806 – Borrowdale – fine clouday
day tone very mellow like – the mildest
of / Gaspar Poussin and Sir GB & on the
whole deeper toned than / this drawing –*
Victoria and Albert Museum, London
(V&A: 192–1888)

When Constable toured the Lake District for two months in 1806 the weather was poor, but the clouds and effects of light and mist are finely differentiated in the watercolours he made there. His annotation likens the tonality of this scenery to landscapes by Gaspard Dughet (1615–1675), known as Poussin, and the amateur Sir George Beaumont (Constable's mentor).

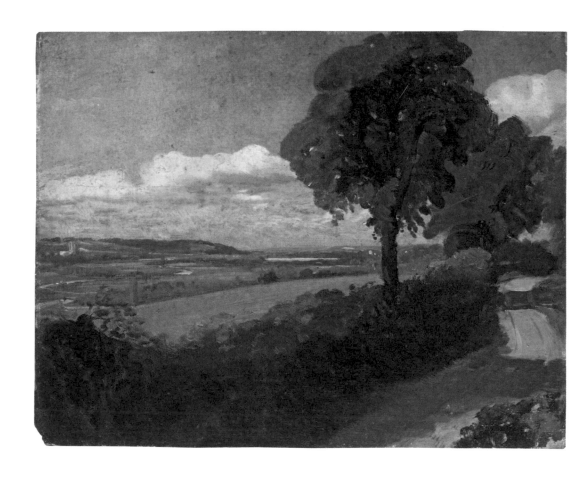

5. *View of Dedham from the Lane*
*Leading from East Bergholt Church*
*to Flatford*, c.1809–10
Oil on paper, later lined onto canvas,
23.9 × 30.3 cm (9⅜ × 11⅞ in.)
Victoria and Albert Museum, London
(V&A: 134–1888)

The paint is applied thick and wet, and the scene is dominated by the looming shadows of the hedgerow and trees, and pools of sunlight on the ploughed field and the rutted lane, which suggest a time around noon. In comparison with Constable's earlier sketches, the foreground forms are weightier and the clouds have more volume.

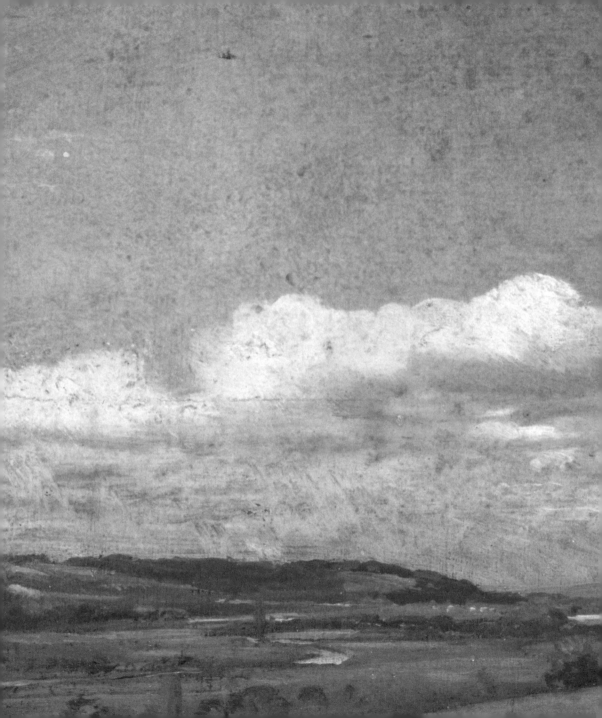

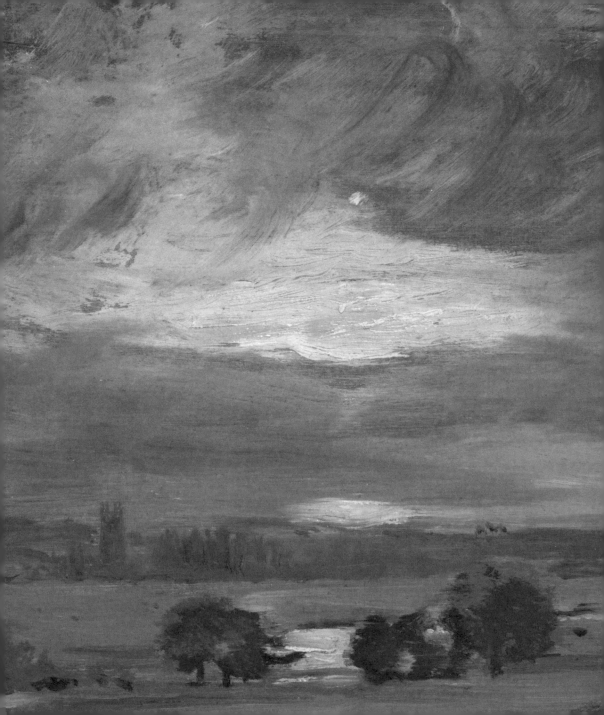

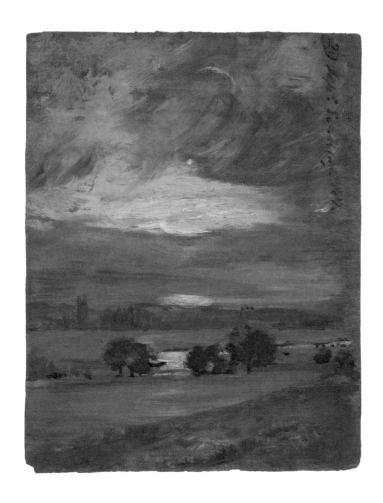

6. *The River Stour: Sunset*, 1810
Oil on canvas, 25 × 19.5 cm
(9³/₄ × 7³/₄ in.)
Inscribed, vertically at right:
*29 Sept. Evening, 1810*
Private Collection

Painted on the reverse of a view of the house of Golding
Constable, the artist's father, this is the second of three
florid sketches of sunrise and sunset made between 27 and
30 September 1810.[71] Beneath an awesome sunset, the silvery
serpentine of the Stour is partly obscured by trees, while
the tower of Dedham church appears at the left.

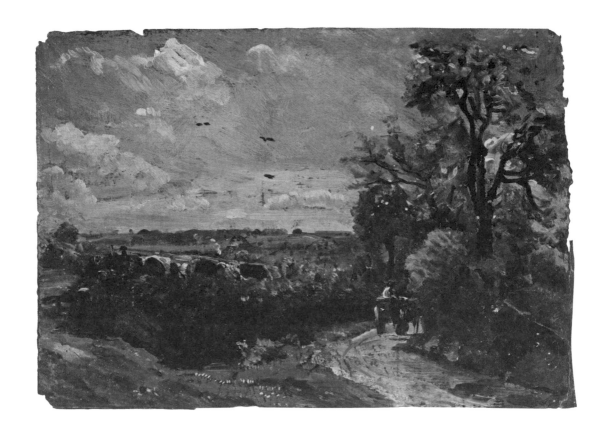

7. *A Cart on the Lane from East Bergholt to Flatford*, 1811
Oil on paper, later lined onto canvas,
15.2 × 21.6 cm (6 × 8½ in.)
Inscribed on stretcher: *17 May 1811*
*L.B.C.* [Lionel Bicknell Constable]
Victoria and Albert Museum, London
(V&A: 326–1888)

This sketch was probably painted from a point a few yards up the lane from *View of Dedham from the Lane Leading from East Bergholt Church to Flatford* (5), and the expressive broken brushwork contrasts markedly with the earlier work. The sky is paler near the horizon and more dynamic, with scudding clouds, a white plume of smoke rising to left of centre and silhouettes of hovering birds.

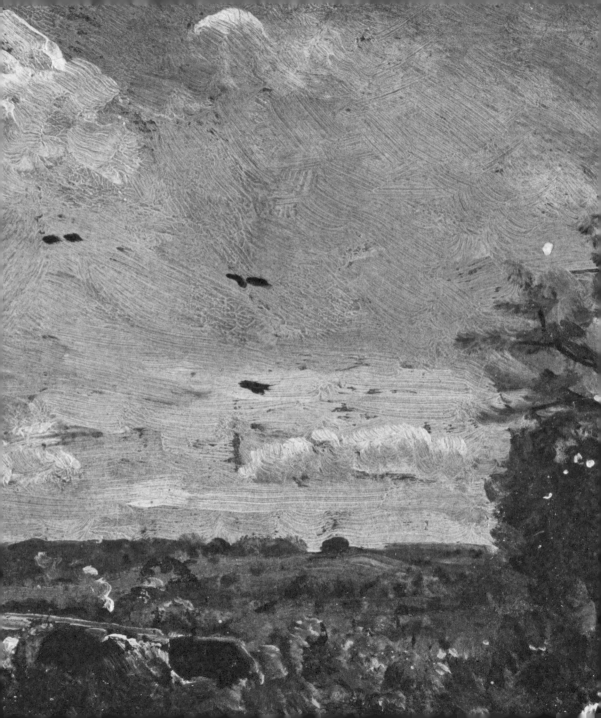

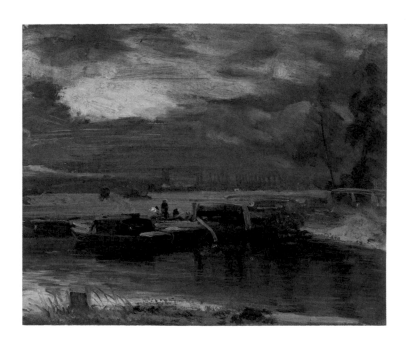

This fluent and dramatic evening view was perhaps painted
at a spring high tide, and shows a barge waiting to enter the
lock with its cross beams at the right. An approaching storm
is suggested by the livid shaft of yellow light which pierces
the dark and threatening sky and is reflected by the water.

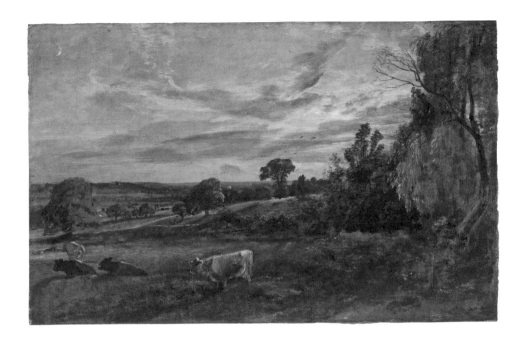

9. *Summer Evening: View near East Bergholt, c.1811–12*
Oil on canvas, later lined,
31.7 × 49.5 cm (12½ × 19½ in.)
Inscribed on stretcher: *"A summer Evening" John Constable R.A. Taken from the fields near E. Bergholt In the distance on the left is Langham Church, in the middle of the picture is Stratford Church and on the higher land in the distance under the tree in the middle is Stoke Church (By Nayland) and Varnished with Fields lack varnish by C.R. Leslie R.A. in 1840*
Victoria and Albert Museum, London
(V&A: 585–1888)

This painting repeats the viewpoint and time of day of *Dedham Vale: Evening*, a sketch made a decade earlier (1). The reddish light of the setting sun shines through the variegated clouds to silhouette the trees and the cattle in the foreground, while the crescent moon is visible at top left. Perhaps the work Constable described as 'quite a pet with me', it was exhibited in 1812 and a mezzotint with the title *Summer Evening* was published in 1831.

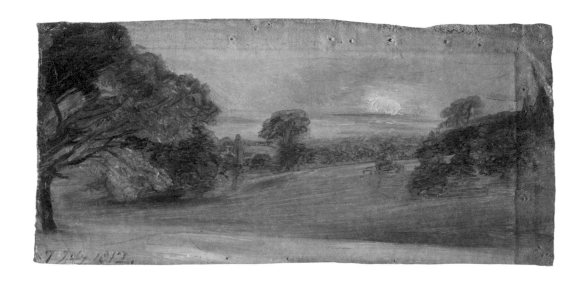

10. *A Landscape near East Bergholt: Evening*, 1812
Oil on canvas, 16.5 × 33.7 cm
(6½ × 13¾ in.)
Inscribed by the artist at lower left: *7 July 1812*
Victoria and Albert Museum, London
(V&A: 146–1888)

This work reuses the corner of a previously stretched canvas with old tacking holes. The volcanic eruption of La Soufrière in the West Indies on 30 April 1812 caused brightly coloured twilights over England between May and October 1812, which were recorded by the meteorologist Luke Howard.

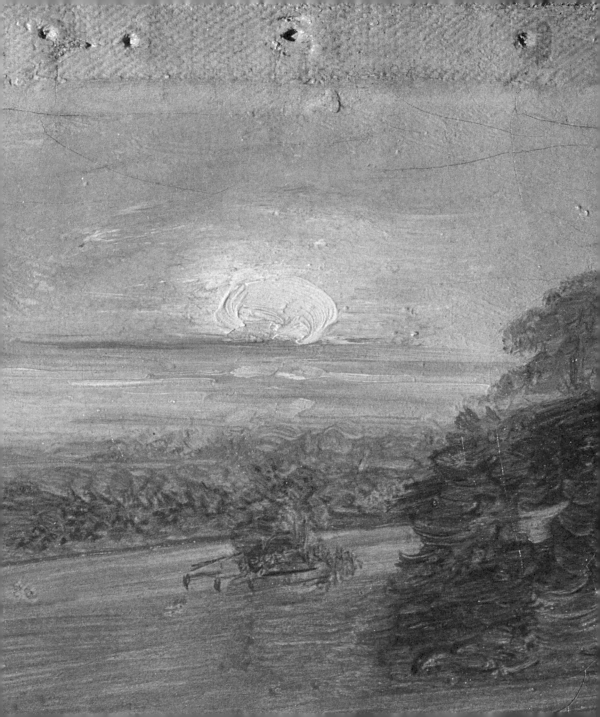

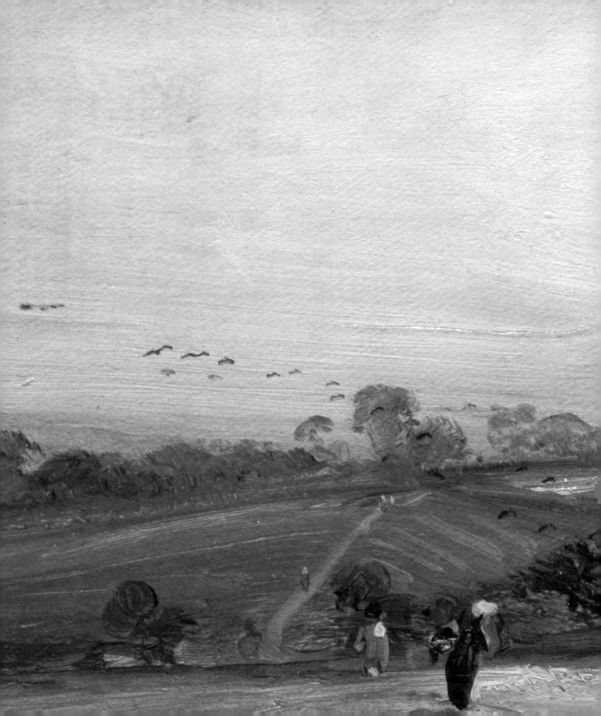

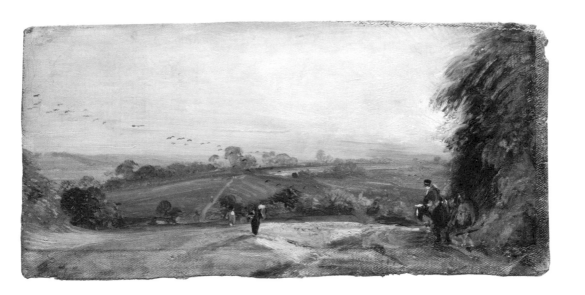

11. *Autumnal Sunset*, c.1812
Oil on paper, laid on canvas,
17.1 × 33.6 cm (6³⁄₄ × 13¹⁄₄ in.)
Inscribed on stretcher: *Autumnal Sun
Set engraved for the 'English Landscape'*
Victoria and Albert Museum, London
(V&A: 127–1888)

The ground of this sketch is covered by green-blue paint,
which tinges the light of the setting sun, partly screened by
overhanging branches at the right. The season is identifiable
from the title *Autumnal Sun Set* of the mezzotint after this
work, published in 1832. The effect was probably suggested by
Rubens's grand autumnal *View of Het Steen*, then owned
by Beaumont.

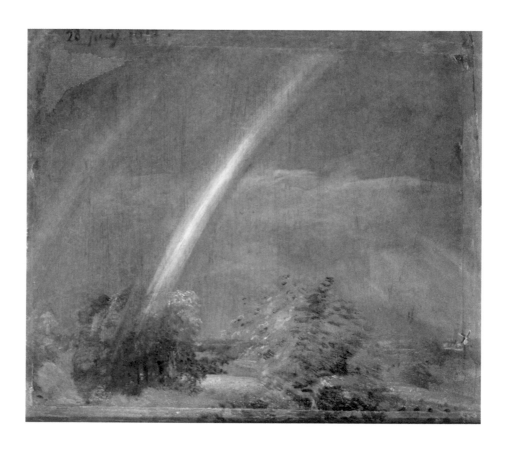

12. *Landscape with a Double Rainbow*, 1812
Oil on paper, laid on canvas,
33.7 × 38.4 cm (13¼ × 15⅛ in.)
Inscribed: *28 July 1812.*
Victoria and Albert Museum, London
(V&A: 328–1888)

Constable would have seen a similarly truncated double rainbow in an engraving after Rubens before painting this, his earliest known sketch of the phenomenon. In July, double rainbows are only seen before 10am and after 4pm. He later learned that the secondary bow should be twice the width of the primary, with reversed colours (*London from Hampstead, with a Double Rainbow,* 65).

46

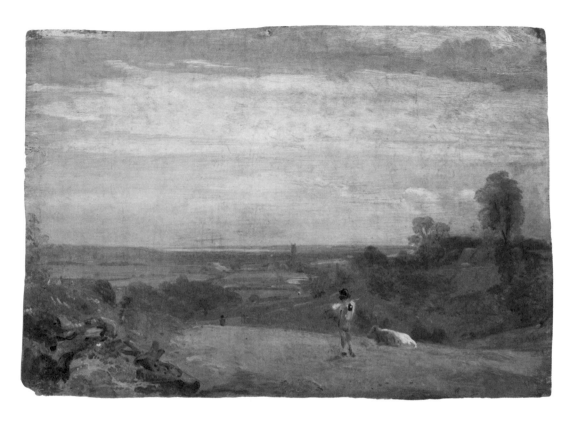

13. *Dedham from Langham*, c.1812
Oil on canvas, 21.6 × 30.5 cm
(8½ × 12 in.)
Victoria and Albert Museum, London
(V&A: 132–1888)

A mezzotint of this scene, with variations, was published with
the title *Summer Morning* in 1831. In a draft accompanying
text, Constable wrote: 'Nature is never seen, in this climate
at least, to greater perfection than at about 9 O'clock in
the mornings of July and August when the sun has gained
sufficient strength to give splendour to the Landscape
"still gemmed with the morning dew".'

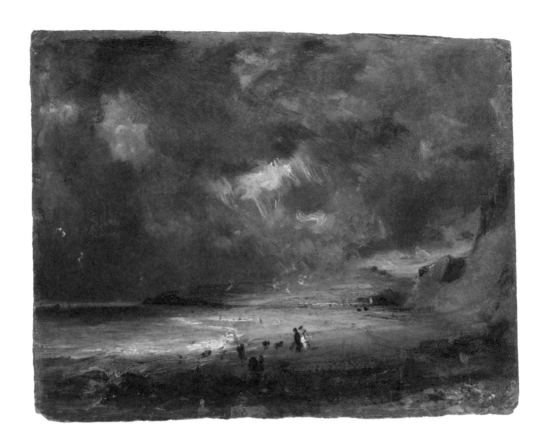

14. *Weymouth Bay*, 1816
Oil on millboard, 20.3 × 24.7 cm
(8 × 9¾ in.)
Inscribed on the back: *JC*
Victoria and Albert Museum, London
(V&A: 330–1888)

This view of Bowleaze Cove in Weymouth Bay, near the parish of Constable's friend John Fisher, was painted between mid-October and early December, during the artist's honeymoon. 1816 was known as 'The year without a summer' on account of the appalling weather, caused by a volcanic eruption in the East Indies. Water drips on the paint show it was raining while Constable worked. He later remarked that this view reminded him of a catastrophic shipwreck which had occurred nearby in 1805.

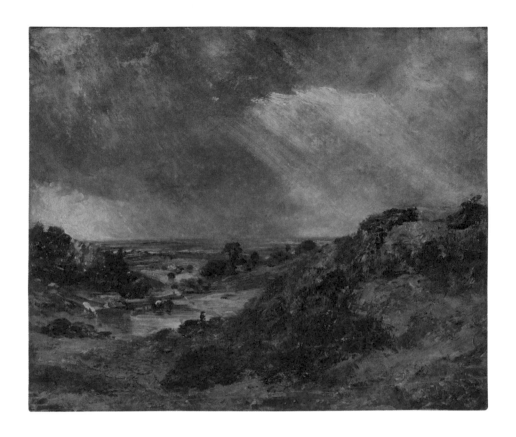

15. *Branch Hill Pond, Hampstead*, 1819
Oil on canvas, 25.4 × 30 cm
(10 × 11⁷/₈ in.)
Inscribed on stretcher: *End of Octr. 1819*
Victoria and Albert Museum, London
(V&A: 122–1888)

This may be one of two 'studies on Hampstead Heath' that
Constable showed to Joseph Farington on 2 November 1819.
Its composition is based on a work by Rubens, *Landscape with
Market People*, with similar diagonal crepuscular rays of sunshine
piercing the clouds. With the most animated sky Constable
had yet painted, this sketch served as the basis for a painting
exhibited in 1828 (*Hampstead Heath: Branch Hill Pond*, 55).

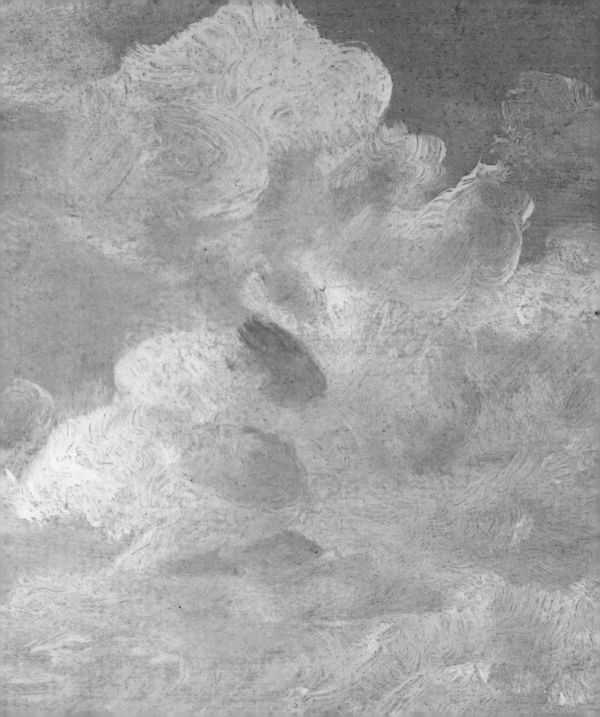

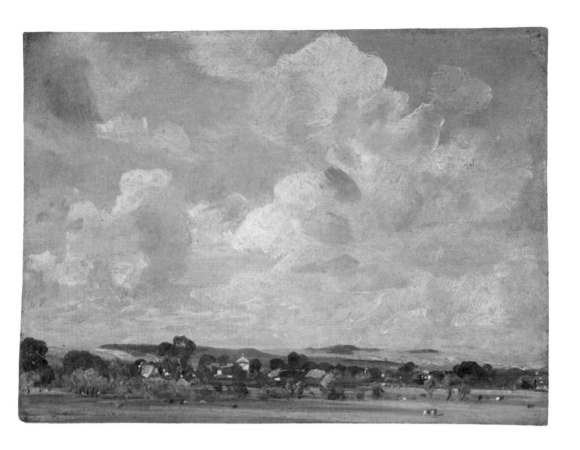

16. *The Village of Harnham*, 1820
Oil on paper, 17.5 × 23.5 cm
(6⅞ × 9¼ in.)
Inscribed on the back: *Village
of Harnham 2d Augt 1820
9 o clock morning looking ?West*
Private Collection

This view of low-lying cumulus above a village near Salisbury
was painted from a window of Archdeacon John Fisher's house
in the cathedral close, and is Constable's earliest oil sketch
annotated with the time of day. The high proportion of sky in
the painting, over three-quarters of the total, exceeds even that
in the seascapes of Willem van de Velde, which the artist had
seen in 1819.

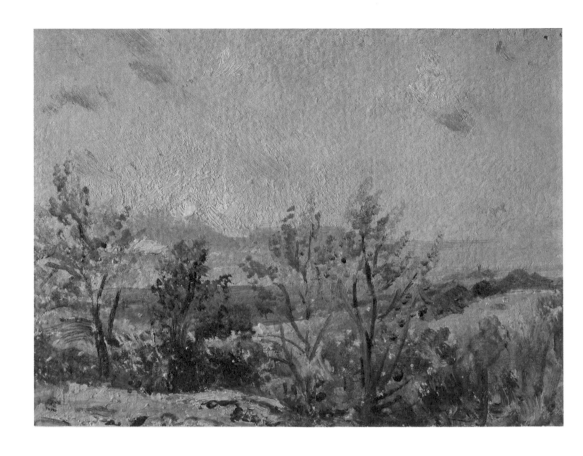

17. *Sketch at Hampstead: Stormy Sunset*, 1820
Oil on card, 12.7 × 17.1 cm (5 × 6¾ in.)
Inscribed on the back: *Hampd. 17th
October 1820 Stormy Sunset. Wind. W.*
Victoria and Albert Museum, London
(V&A: 147–1888)

This study emphasizes the golden light illuminating the
foreground, and the silhouettes of the foreground shrubbery.
Its depiction of 'wisps of small cumulus being dragged across
the sky by the wind' agrees with the references to 'high winds',
'flying clouds' and rain showers recorded in several weather
diaries on that day.

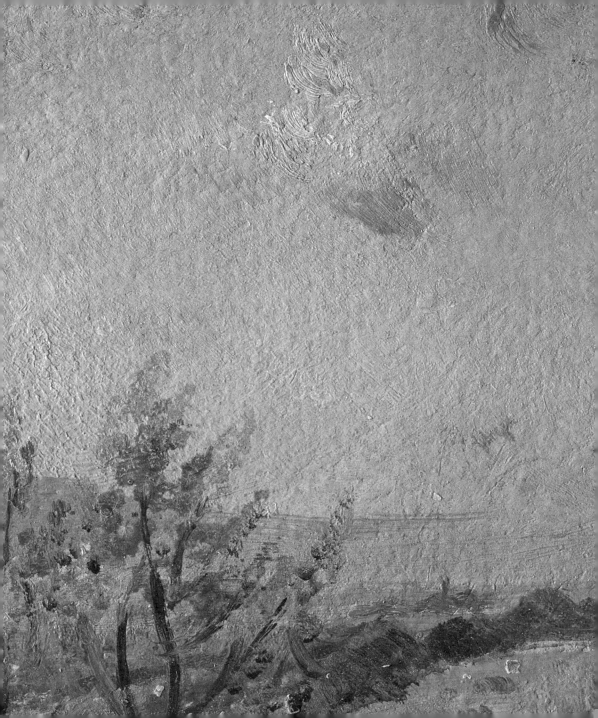

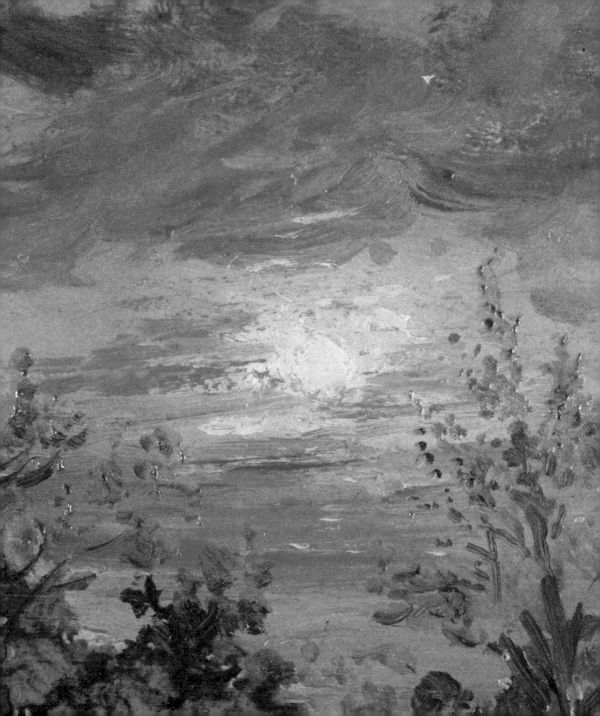

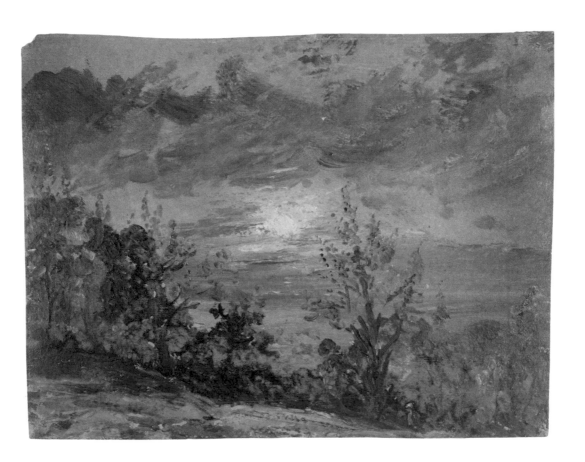

18. *Sketch at Hampstead: Evening*, 1820
Oil on card, 15.9 × 20.3 cm (6¼ × 8 in.)
Inscribed by the artist on the back:
*28th Octr. fine Evening Wind Gentle*
*at S.W.*, and signed: *J.C.*
Victoria and Albert Museum, London
(V&A: 159–1888)

The black clouds may be pollution from coal fires, more marked on days such as this, when the temperature in London barely exceeded 10°C. The similarity to *Sketch at Hampstead: Stormy Sunset* (**17**), dated 17 October 1820, shows that Constable returned to the same spot at the same time 11 days later.

This study was painted in the studio, using outdoor sketches made a decade earlier, to establish the balance of light and shade in Constable's best-known composition, which was first exhibited in 1821 with the title 'Landscape: Noon'. The overcast sky belies the sunlight illuminating the distant meadow. In the final version, the light source is visible as a patch of clear blue sky at top right, which enlivens the stream with reflections and reveals the season as high summer.

19. *Full-scale Study for 'The Hay Wain'*, 1820–1
Oil on canvas, subsequently lined, 137 × 188 cm (54 × 74 in.)
Victoria and Albert Museum, London
(V&A 987–1900)

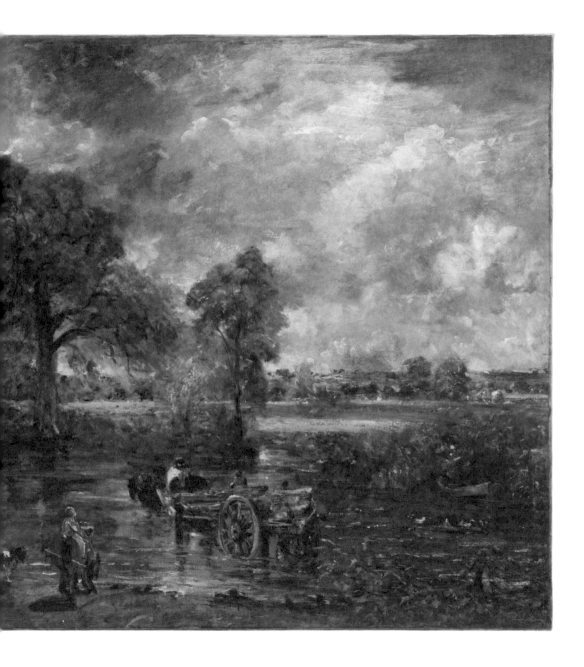

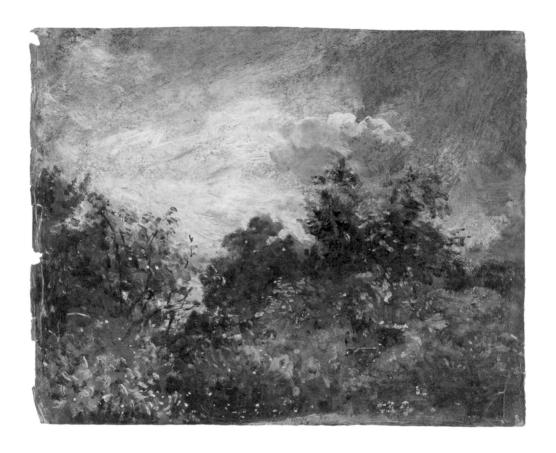

20. *Study of Sky and Trees*, 1821
Oil on paper, 24.1 × 29.8 cm
(9½ × 11¾ in.)
Inscribed in ink by the artist
on the back: *September 3d. Noon.*
*very sultry. with large drops of Rain*
*falling on my palate light air from S.W.*
Victoria and Albert Museum, London
(V&A: 151–1888)

The sky shows the base of a dark cumulus cloud, with some
light rain. The date of this sketch is confirmed by a diary of the
weather at Kew in south-west London, which records 'Mostly
Cloudy some drops', corresponding to the rain that splattered
Constable's palette as he worked. It is his first sketch to
emphasize the highlights on the clouds above.

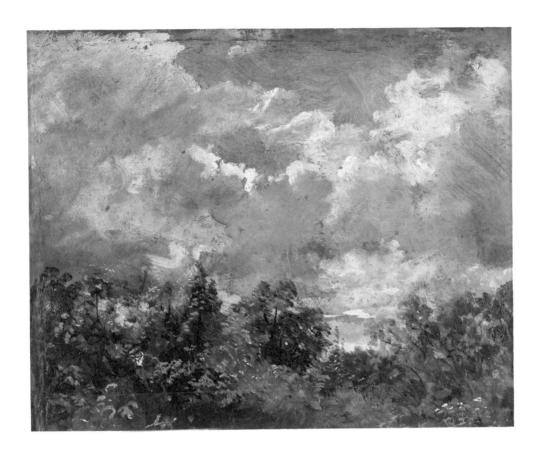

21. *Study of Sky and Trees*, 1821
Oil on paper, 24.8 × 29.8 cm
(9¾ × 11¾ in.)
Victoria and Albert Museum, London
(V&A: 162–1888)

This undated sketch is stylistically comparable with the *Study of Sky and Trees* (20) made on 3 September 1821, but its more developed plump cumulus clouds are more like those in *Cloud Study* (22), dated 10 September.

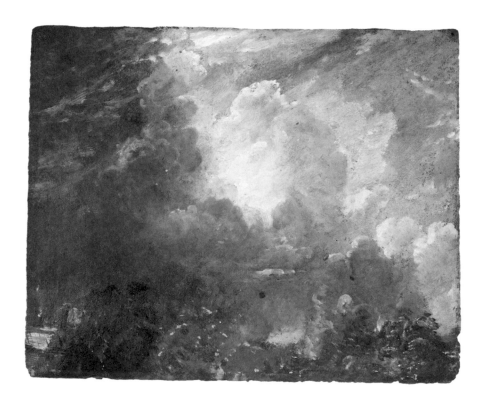

22. *Cloud Study*, 1821
Oil on paper, 21.6 × 29.2 cm
(8½ × 11½ in.)
Inscribed by the artist on the back:
*Sepr. 10 1821 Noon. gentle wind at*
*west / very sultry. after a heavey* [sic]
*shower with thunder / accumulated*
*thunder clouds passing slowly away*
*to the south East. Very bright and hot.*
*All the foliage sparkling with the*
*[...] and wet.*
Private Collection

An hour earlier, Constable had painted another sketch,
its whereabouts now unknown, which is inscribed: 'Sultry
with warm[?] rain falling large heavy clouds [...?]
a heavy downpour and thunder'. Weather diaries confirm
that a thunderstorm occurred late that morning. Here,
black thunderclouds disperse to the left as sunlight breaks
through in the centre of the composition. The high viewpoint
suggests the artist was working from an upstairs window,
probably because of the unsettled weather.

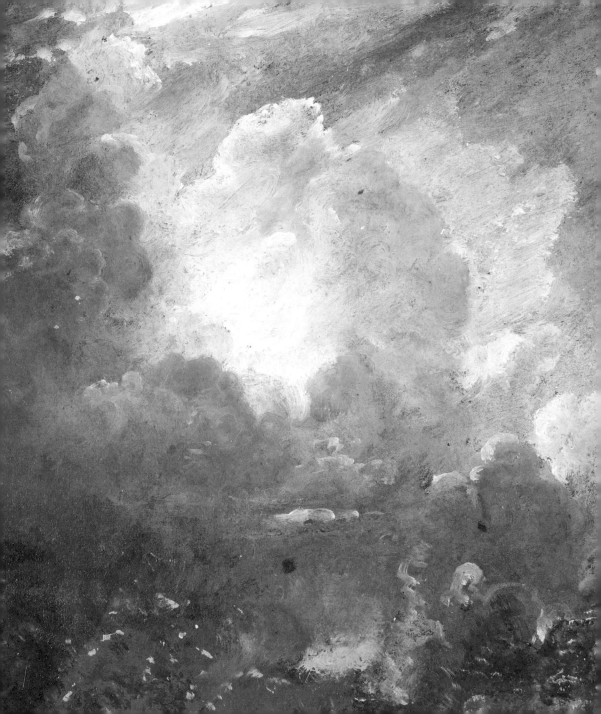

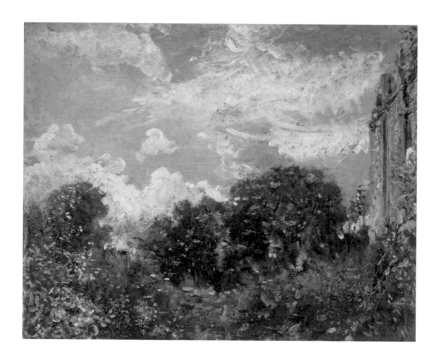

23. *Study of Sky and Trees, with a Red House, at Hampstead,* 1821
Oil on paper, 24.1 × 29.8 cm
(9½ × 11¾ in.)
Inscribed in ink by the artist on the back: *Sepr. 12. 1821. Noon. Wind fresh at West [...]. Sun very Hot. looking southward exceedingly bright wind & Glowing, very heavy showers in the Afternoon but a fine evening. High wind in the night.*
Victoria and Albert Museum, London
(V&A: 156–1888)

Records indicate that a showery morning preceded the clear and sunny midday depicted here. The artist initially provided a description of the weather on 10 September on the reverse, which he deleted, and replaced with notes for the correct day. This suggests he kept his own weather diary, from which he transcribed notes.

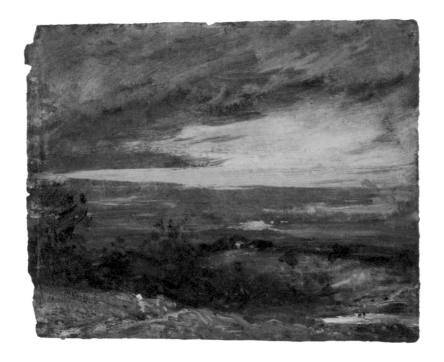

24. *Hampstead Heath, Looking towards Harrow, at Sunset*, 1821
Oil on paper, 24.1 × 29.2 cm
(9½ × 11½ in.)
Inscribed on the back (probably by the artist): *Sepr. 12. 1821 Sun setting over Harrow This appearance of the Evening was [?aft] just after a very heavy rain more rain in the night and a very [?light] wind which continued all the day following – [the 13th] while making this sketch observed the Moon rising very beautifully [?in the] due East over the heavy clouds from which the late showers had fallen., and Wind gentle [...] increasing from the North west. Rather.*
Private Collection

Following heavy showers in the afternoon, the clearing sky allowed Constable to venture out to paint the sunset, around 6.20pm. At the bottom right, light glances off the surface of Branch Hill Pond. On 20 September the artist wrote to his friend John Fisher: 'I have likewise made many skies and effects…We have had noble clouds & effects of light & dark & colour – as is always the case in such seasons as the present.'

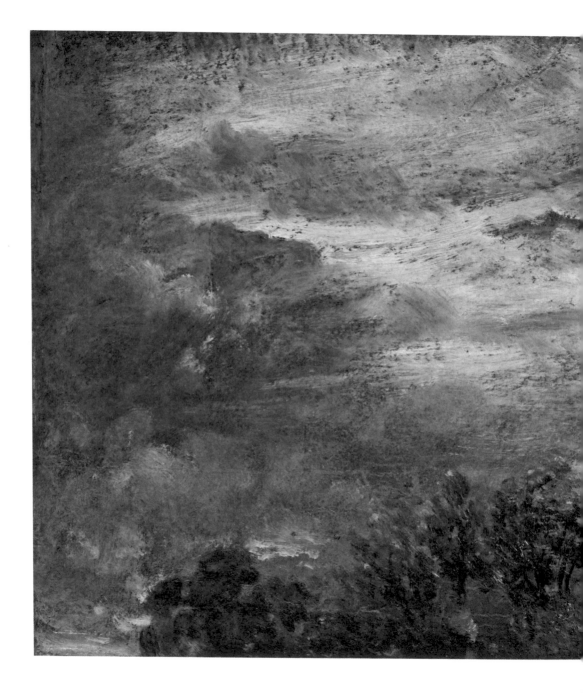

In the inscription the year is illegible, but weather diaries for 24 September 1821 agree with the artist's notes that the day was overcast and warm for the season, with a westerly wind, thus identifying the year this sketch was painted. Constable portrayed the edges of the large cumulus clouds presaging the rain which followed that afternoon.

25. *Study of Sky and Trees*, 1821
Oil on paper, 24.8 × 30.5 cm
(9¾ × 12 in.)
Inscribed in ink by the artist
on the back: *Sept. 24th.* [words
deleted] *10 o'clock morning wind
S.W. warm & fine till afternoon,
when it rained & wind got more
to the north*; inscribed: *JC.*
Victoria and Albert Museum, London
(V&A: 167–1888)

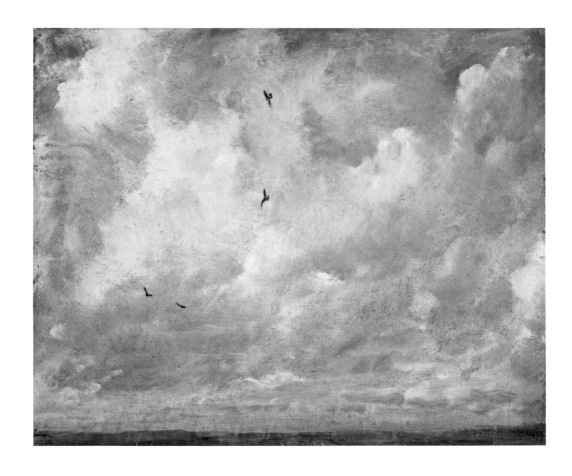

26. *Stratocumulus Clouds*, 1821
Oil on paper, 25.5 × 30.5 cm
(9⅞ × 12 in.)
Inscribed by the artist on the back: *Sepr.
28. 1821 Noon – looking North West windy
from the S.W. large bright clouds flying
rather fast very stormy night followed.*
Yale Center for British Art, New Haven
(B1981.25.155)

The birds wheeling overhead are an unusual feature of this study. A small landscape strip is visible at the bottom of the painting, while the bluer strip at the right was left by an old mount, showing how the exposed surface has discoloured. This sketch agrees with the fine but cloudy weather recorded in weather diaries. Luke Howard would have called such clouds 'extensive cumulus' or 'cirro-stratus'.

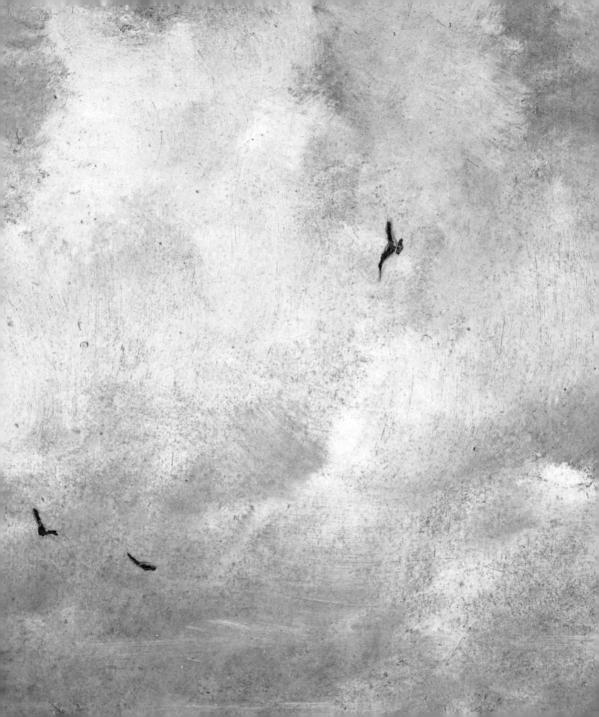

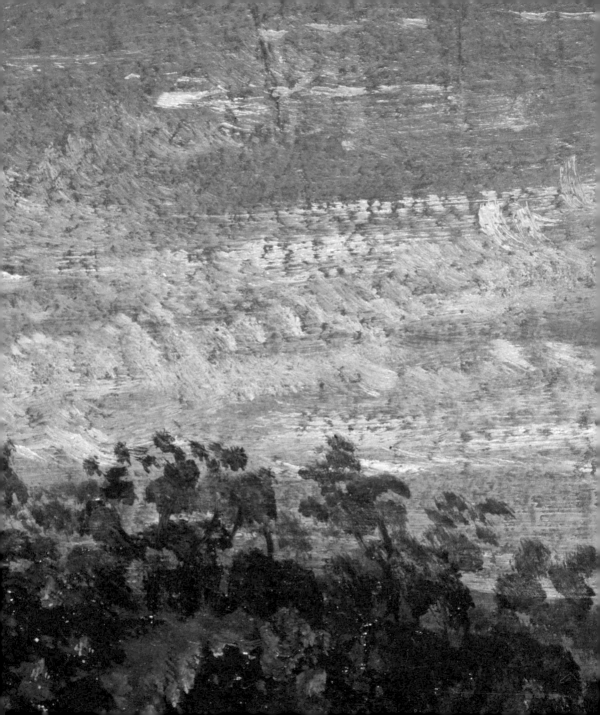

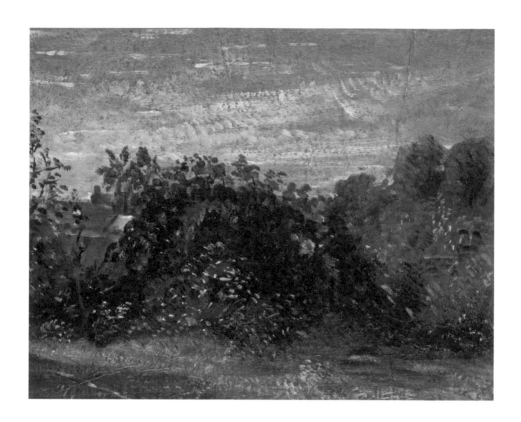

27. *Study of Sky and Trees*
*at Hampstead, 1821*
Oil on paper, 24.5 × 29.8 cm
(9⅞ × 11¾ in.)
Inscribed in ink by the artist
on the back: *Ocr. 2d.1821. 8. To 9.*
*Very fine still morning. Turned out a may*
*day. Rode with Revd. Dr. White. Round*
*by Highgate. Muswell Hill. Coney Hatch.*
*Finchley. By Hendon Home*; inscribed: *JC.*
Victoria and Albert Museum, London
(V&A: 168–1888)

Perhaps working from a vantage point in his garden, with the chimneys of neighbouring houses poking through the still foliage, Constable began this sketch an hour after sunrise, with the low sun illuminating wispy, high-level cirrus and cirrostratus. Howard recorded that this rather cool day was 'Remarkably fine', while the painter likened it to 'a may day' and later went out riding.

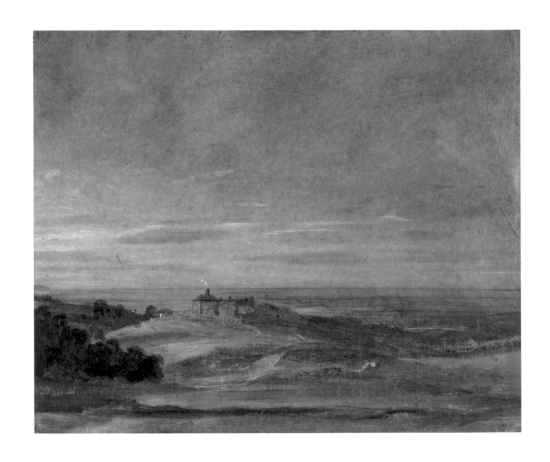

28. *Hampstead Heath:*
*Branch Hill Pond*, 1821
Oil on paper, 24.8 × 29.8 cm
(9¾ × 11¾ in.)
Inscribed by the artist on the back:
*Octr – 13th. 1821. – 4 to 5 afternoon –*
*very fine with Gentle Wind at N.E.*
Victoria and Albert Museum, London
(V&A: 781–1888)

The prominent cottage called 'The Salt Box' was situated on the edge of Hampstead Heath. Weather diaries confirm that 13 October 1821 was fine and clear. An hour or two before sunset, Constable depicts smoke drifting lazily from the cottage's chimney against a blue sky enlivened by wreaths of stratocumulus.

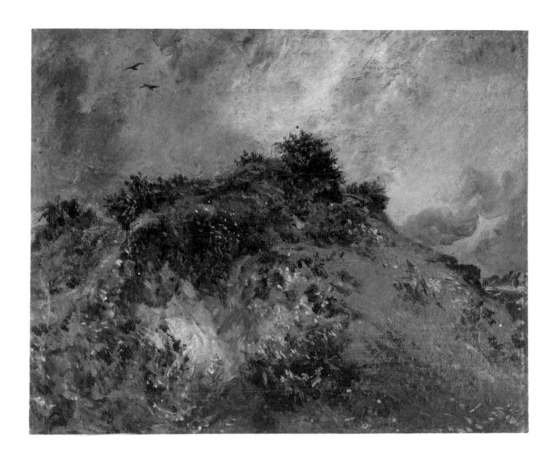

29. *A Sandbank at Hampstead Heath*, 1821
Oil on paper, 24.8 × 29.8 cm
(9¾ × 11¾ in.)
Inscribed by the artist on the back:
*Novr. 2d 1821. Hampstead Heath windy*
*afternoon*; inscribed: *J.C.* in monogram
Victoria and Albert Museum, London
(V&A: 164–1888)

Weather diaries indicate that on this overcast and windy day in late autumn the temperature exceeded 17°C. The warm weather allowed Constable to make his final sky study with weather notes of the year. The following day he wrote: 'The last day of Octr was indeed lovely so much so that I could not paint for looking – my wife was walking with me all the middle of the day on the beautifull heath.'

Constable used a fragment of previously stretched canvas with its tacking margins folded out and flattened as this support. Shortly before sunset, the sun pierces dark clouds to silhouette a tree and a rider watering his horse at the pond, which mirrors the sunlight. The artist later flipped this canvas and sketched a study of a kiln in a clearing on its reverse.

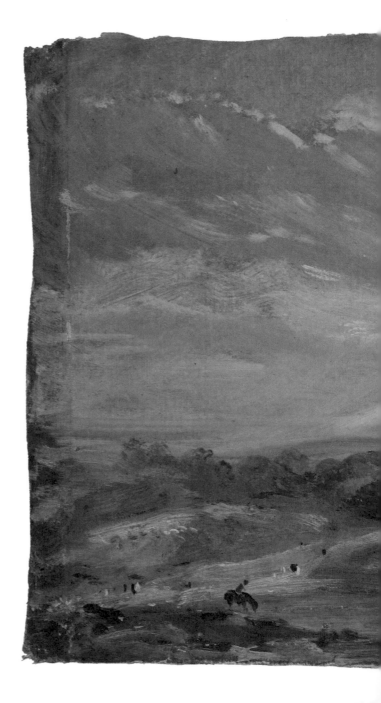

30. *Branch Hill Pond, Hampstead,*
*c.*1821/2
Oil on canvas fragment, later lined,
24.5 × 39.4 cm (9⅝ × 15½ in.)
Victoria and Albert Museum, London
(V&A: 125–1888)

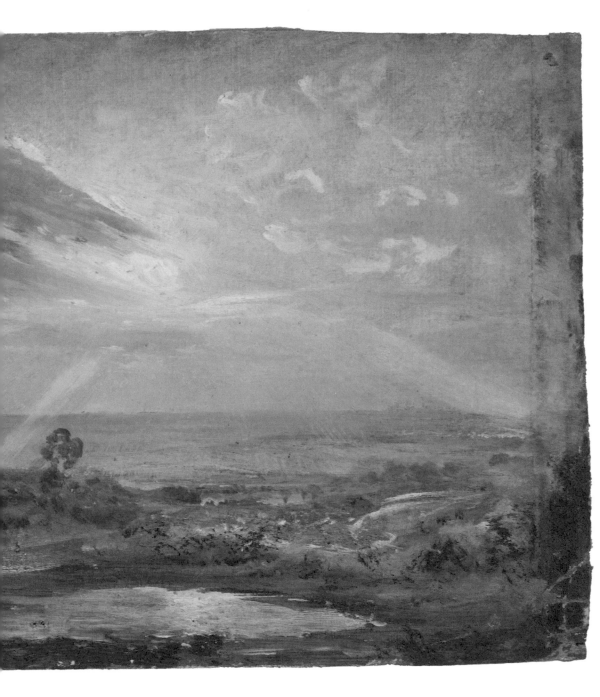

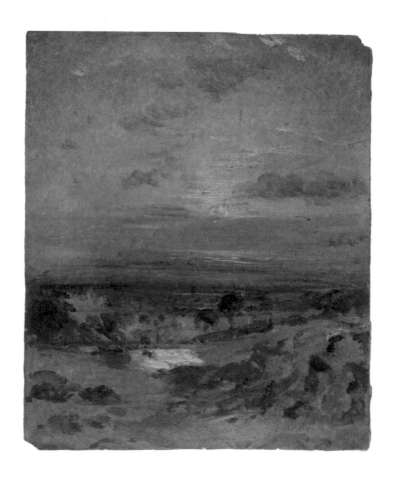

31. *Branch Hill Pond: Evening*, *c*.1821/2
Oil on paper, 22.9 × 19 cm (9 × 7½ in.)
Victoria and Albert Museum, London
(V&A: 339–1888 recto)

The sun's position suggests that this vertical composition was painted around September. The view is painted looking westwards into the richly coloured sunset, with the surface of the pond reflecting the light of the dying sun amidst the surrounding gloom. Constable later painted a pure cloud study (**32**) on the reverse.

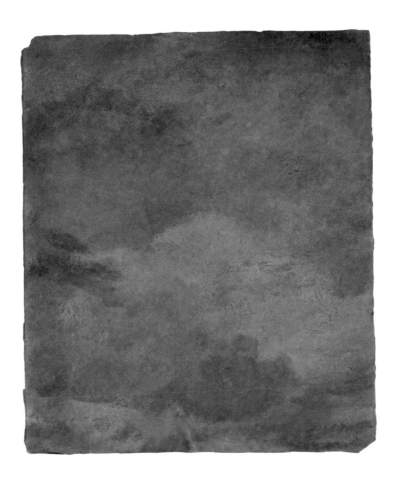

32. *Cloud Study*, c.1821/2
Oil on paper, 22.9 × 19 cm (9 × 7½ in.)
Victoria and Albert Museum, London
(V&A: 339–1888 verso)

On a pale pink ground, this cloud study was added to the reverse of a sketch of Branch Hill Pond (31). The yellowish passages in the clouds were probably caused by later deterioration of the paint. The vertical format is unusual for a pure cloud study. Another, slightly larger, vertical cloud study,[72] more expressionist in character, bears the date 12 August 1822.

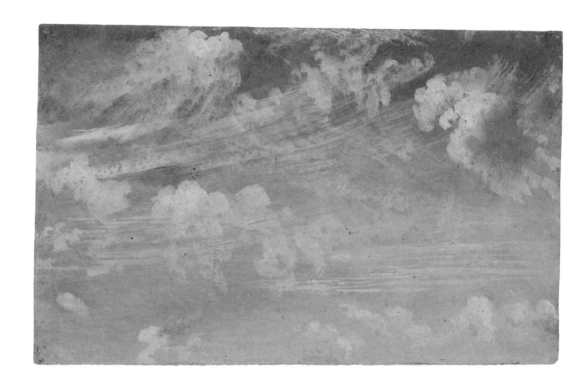

*33. Study of Cirrus Clouds, c.1821/2*
Oil on paper, 10.4 × 17.8 cm (4½ × 7 in.)
Inscribed on the back, probably by the
artist: *?cirrus*; written over in another
hand: *Painted by John Constable R.A.*
Victoria and Albert Museum, London
(V&A: 784–1888)

This is one of Constable's best-known sky studies, described by John Thornes as 'a superb rendering of cirrus clouds with small tufts of cumulus below'. Its small size and technique are uncharacteristic, as the sheet was first painted blue, and the clouds added. The use of the term 'cirrus' suggests acquaintance with recent meteorological research. This sketch may have been painted later, when Constable was compiling notes on clouds in the 1830s.

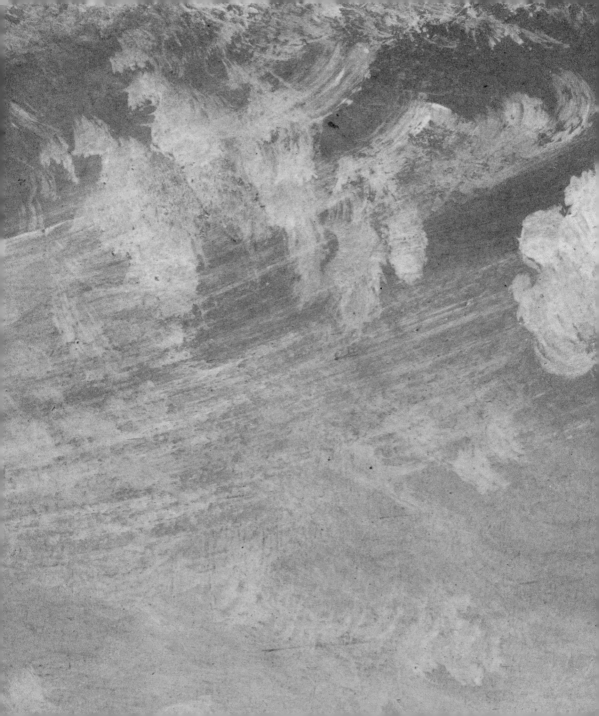

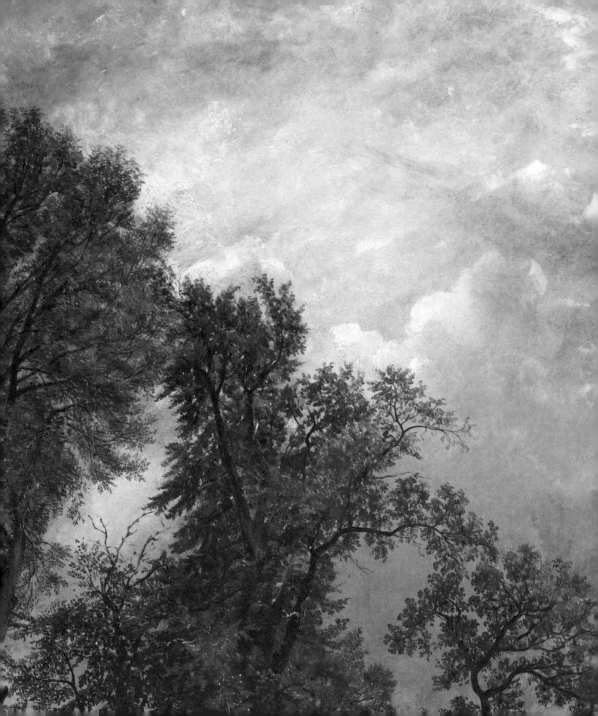

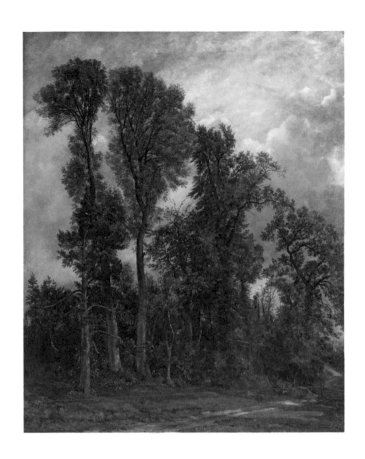

34. *Trees at Hampstead:*
*the Path to Church, c.1821/2*
Oil on canvas, 91.4 × 72.4 cm
(36 × 28½ in.)
Victoria and Albert Museum, London
(V&A: 1630–1888)

Constable mentioned on 20 September 1821: 'I have done some studies carried further than I have yet done any, particularly a natural (but highly elegant) group of trees, ashes, elms & oak &c.' This work was probably exhibited in 1822 as *A Study of Trees from Nature*, which suggests it was painted at least partly out of doors. A uniform screen of clouds provides a foil to this exactly differentiated portrait of trees near Hampstead parish church, where the artist and his wife were later buried.

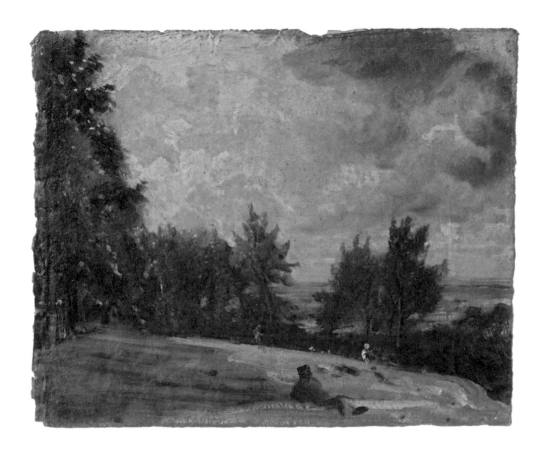

35. *A View at Hampstead with Trees and Figures*, 1822
Oil on paper, 24.2 × 29.8 cm
(9½ × 11¾ in.)
Inscribed by the artist on the back:
*July, 30th 1822. Noon under the Sun*, and
inscribed: *M.L.* [Maria Louisa Constable]
Victoria and Albert Museum, London
(V&A: 165–1888)

Despite Constable's inscription, weather diaries for this day record only average temperatures for the season with cloud and rain showers, consistent with the large cumulus depicted here. In the foreground a lying figure shelters his head from the sunlight in the shade of the trees, while a child plays in the background.

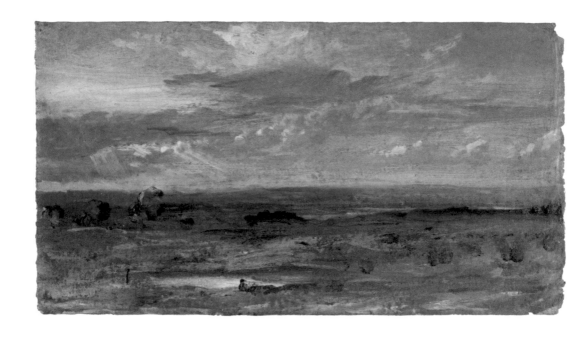

36. *A View in Hampstead: Evening*, 1822
Oil on paper, 16.2 × 30.5 cm
(6½ × 11¾ in.)
Inscribed by the artist on the back:
*Evning, 31st July, 1822 Shower
approaching*, and in pencil: *Schroth*;
inscribed in ink: *Evening July 1822
J Constable R A Hampstead*; also *9 3d.*
Victoria and Albert Museum, London
(V&A: 337–1888)

The dark anvil-shaped cloud in the centre may be the largest
of all clouds, known as cumulonimbus, accompanied by smaller
cumulus. These are associated with unstable weather and
thunder. At the left, the crepuscular rays of the setting sun
slant through, while the silvery patch of water may be Branch
Hill Pond. Constable perhaps added the name of his French
dealer, Claude Schroth, because Schroth considered ordering
a painting based on this sketch; however, no painting is known.

82

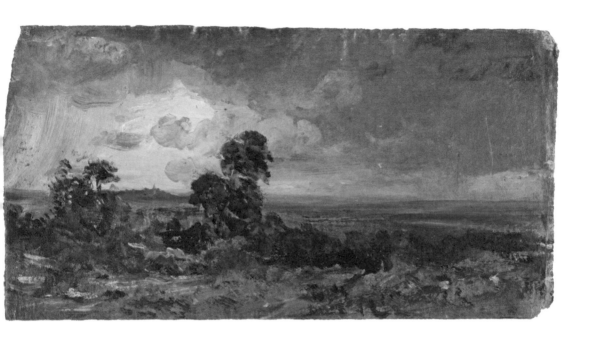

37. *Hampstead: Stormy Sunset*, 1822
Oil on paper, 16.2 × 30.5 cm
(6³/₈ × 12 in.)
Inscribed by the artist on the back:
*July 31.1822. Stormy sunset*
Victoria and Albert Museum, London
(V&A: 336–1888)

Painted shortly after *A View in Hampstead: Evening* (**36**), this sketch depicts the arrival of the previously approaching storm. Rain falls at the left, while on the horizon, framed by two trees, the distant hill and spire of Harrow church are silhouetted by the yellow light of the setting sun. The broad and vigorous brushstrokes suggest the artist was working at speed, against the failing light in the face of oncoming rain.

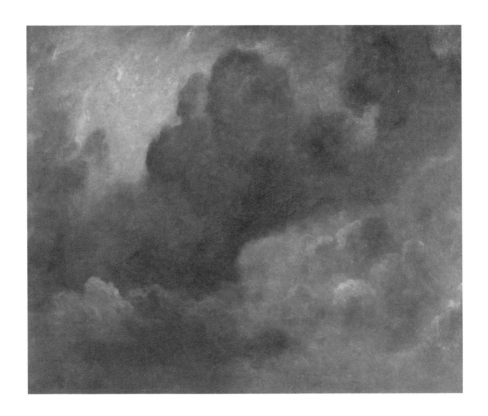

38. *Cloud Study*, 1822
Oil on paper (re-laid on board),
47.5 × 57.5 cm (18³⁄₄ × 22¹⁄₂ in.)
Inscribed on the back: *27 augt 11,
o clock Noon looking Eastward large
silvery [...] wind gentle at S West.*
Tate
(T6065)

This is one of four skyscapes of this large size which are among the '50 carefull studies of skies, tolerably large' Constable mentioned on 22 October. It depicts the huge rain-bearing cumulus that preceded the thunderstorms mentioned in weather diaries for 27 August 1822 between 12 noon and 2pm. These large sky studies are more generalized than the artist's smaller sketches.

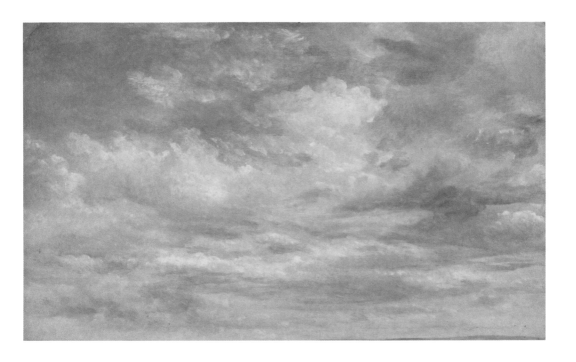

39. *Cloud Study*, 1822
Oil on paper, 30 × 48.8 cm
(14½ × 19¼ in.)
Inscribed by the artist on the back:
*5th of September, 1822, 10 o'clock.*
*Morning looking South-East very brisk*
*wind at West, very bright and fresh grey*
*clouds running very fast over a yellow*
*bed, about half way in the sky. Very*
*appropriate for the coast at Osmington.*
National Gallery of Victoria, Melbourne
(Inv. 455/4)

The inscription suggests that Constable considered using this sketch in a painting of Osmington Bay in Dorset, but there is no sign of this in his views of that location painted in 1824. Constable later sent several sky studies to C.R. Leslie, who by 1843 owned 20, including this one.

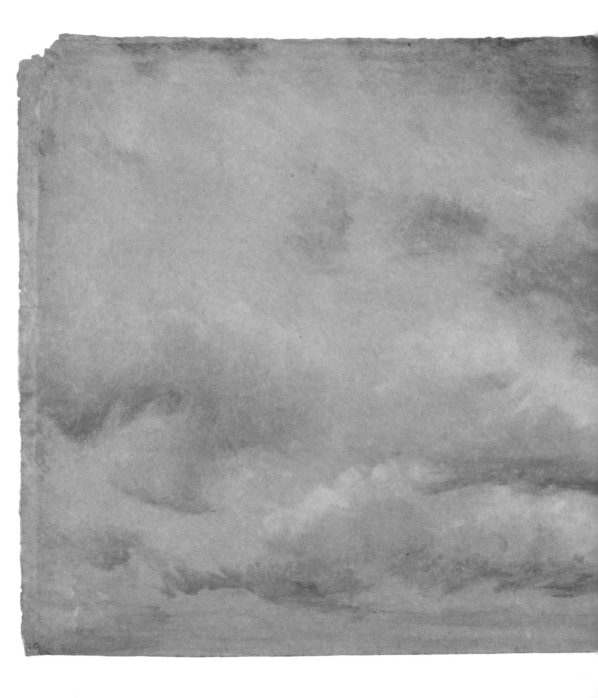

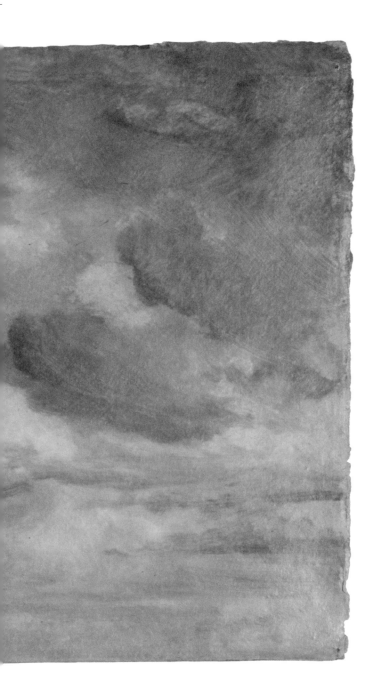

Like the slightly larger sketch Constable painted two hours earlier on the same fresh and dry day (39), this study depicts abundant low stratocumulus clouds, too meagre to bear rain, blown rapidly in a warm and strong westerly airstream.

40. *Cloud Study*, 1822
Oil on paper, 29.8 × 48.3 cm
(11¾ × 19 in.)
Inscribed in ink by the artist on the
back: *Sept. 5.1822. looking S.E. noon.*
*Wind very brisk. & fresh. Clouds.*
*moving very fast. with occasional*
*very bright openings to the blue.*
Victoria and Albert Museum, London
(V&A: 590–1888)

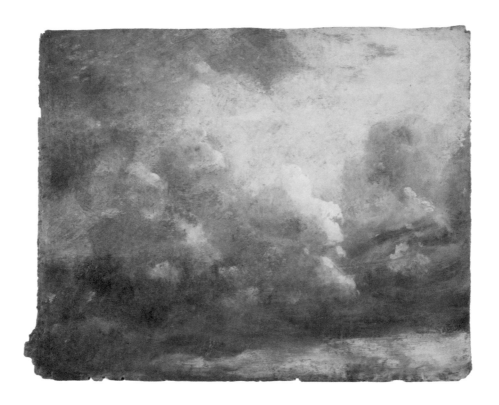

41. *Cloud Study*, 1822
Oil on paper, 24.5 × 29.7 cm
(9⅝ × 11¾ in.)
Inscribed by the artist on
the back: *Sepr. 6. 1822 Noon.*
*Gentle wind at west. hot & fine.*
Private Collection

The first of two sketches made in succession on a warm day for the season, in the low 20s Celsius. Here, the convection of rising warm and sinking cool air has caused rows of cumulus parallel to the direction of the wind, while the dark cloud base suggests showers. In the following sketch,[73] made between noon and 1pm, the sky is much brighter, and Constable inscribed on it that the sky has 'much the look of rain all the morning, but very fine and grand all the afternoon and evening'.

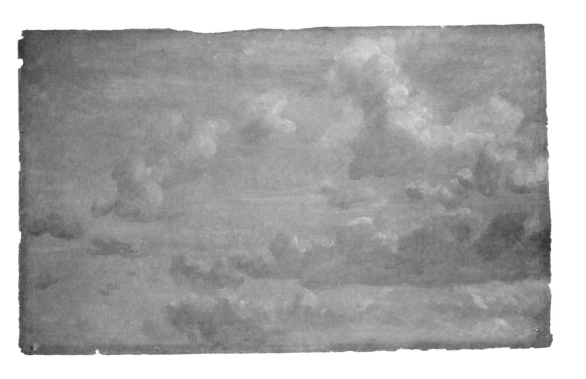

42. *Cloud Study*, 1822
Oil on paper, laid on board,
30.5 × 49.2 cm (12 × 19¼ in.)
Inscribed by the artist on the back:
*Sepr. 21 1822. looking South brisk Wind*
*at East Warm & fresh 3 oclo afternoon.*
Courtauld Gallery, London
(P.1952.RW.69)

This is the second of two sketches made on a day described in weather diaries as 'Fine' with 'Flying Clouds'. An inscription shows that the previous one[74] was made at 1.30pm, also looking south in similar weather. Here, Constable depicts rows of 'fair weather' cumulus moving rapidly from left to right. The distant bluish stream of cloud at lower left, overlapped in places by smaller puffs, seems at the point of dissolving.

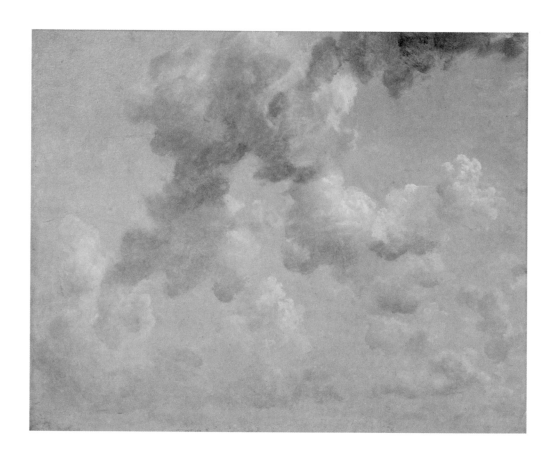

43. *Cloud Study*, 1822
Oil on paper, laid on canvas,
48 × 59 cm (18⅞ × 23¼ in.)
Inscribed on the back (covered by lining
canvas): *31st Sepr. 10–11 o'clock morning
looking Eastward a gentle wind to East*
Ashmolean Museum, Oxford
(WA1933.7)

Constable mistook the date on this, one of his largest sky studies, which portrays the fair and rather warm weather around 18°C recorded on 1 October 1822. The apparent convergence of the cumulus is unnatural, but the strange angle at which the clouds are depicted may have been caused by them moving directly towards the artist as he painted into the wind.

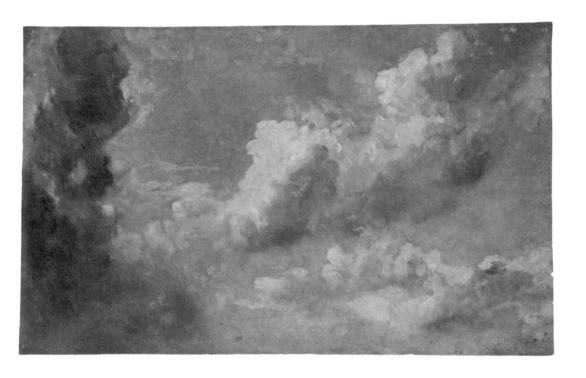

44. *Cloud Study,* 1822
Oil on paper, 19.8 × 32 cm
(7½ × 12⅝ in.)
Inscribed on the back:
*Painted by John Constable RA*
*bought by W.P. Frith*
Private Collection

Flanked by a flurry of dark cumulus, the voluminous central
cloud is thrown into relief by a white highlight at upper left
and a corresponding patch of shadow at bottom right. Its label
shows this is one of 17 Constable 'Studies of Skies' bought at
C.R. Leslie's sale in 1860 by the painter William Powell Frith
(1819–1909).

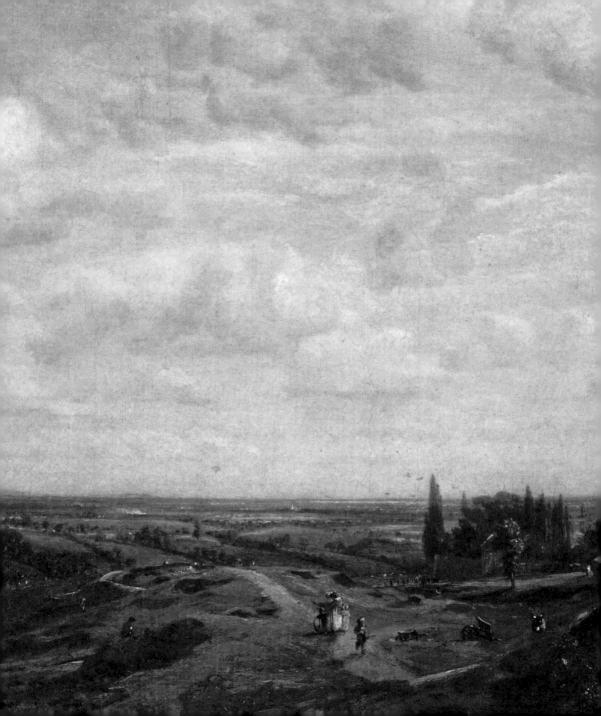

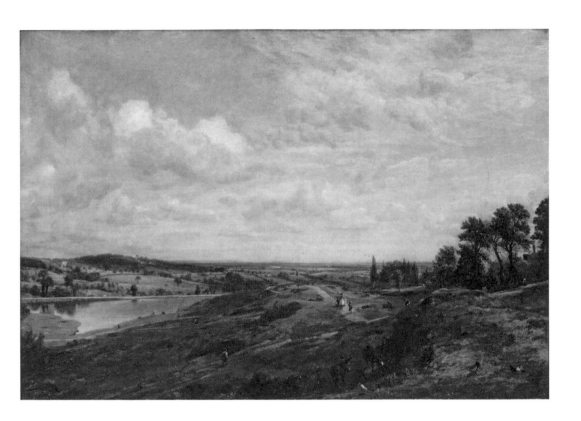

45. *Hampstead Heath*
*(The Vale of Health)*, *c.*1822
Oil on canvas, 53.3 × 77.6 cm
(21 × 30½ in.)
Victoria and Albert Museum, London
(V&A: FA.36[0])

Fresh colours and a placid sky, with quiet distant clouds, suggest high summer. In 1866 this panoramic view was called 'a minute and careful study, painted on the spot' by the art historians Richard and Samuel Redgrave, who likened it to recent works by the Pre-Raphaelites. The figures would have been added in the studio, but their shadows locate the light source, beyond the upper right edge of the scene.

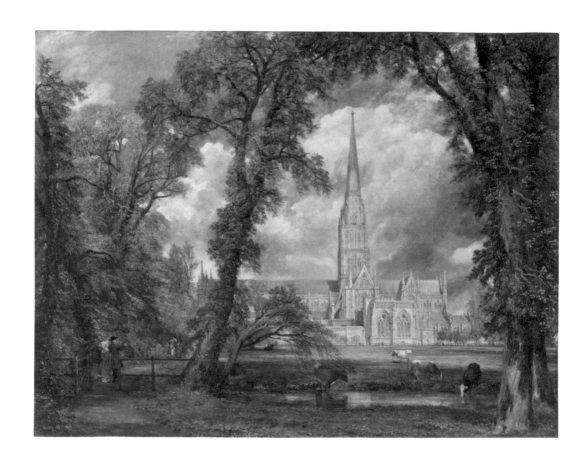

46. *Salisbury Cathedral from
the Bishop's Grounds*, 1823
Oil on canvas, 87.6 × 111.8 cm
(34½ × 44 in.)
Signed: *John Constable A.R.A.
London 1823* [indistinct]
Victoria and Albert Museum, London
(V&A: FA.33 [o])

This composition closely follows an oil sketch Constable
made at Salisbury in the summer of 1820,[75] with the same
configuration of trees, resembling a Gothic arch, enclosing
the view of the cathedral. At the left, the bishop and his wife
admire the grounds they have had laid out. Because his patron
objected to the dark cloud at the right, the artist painted
a replica with 'a clear blue sky'.

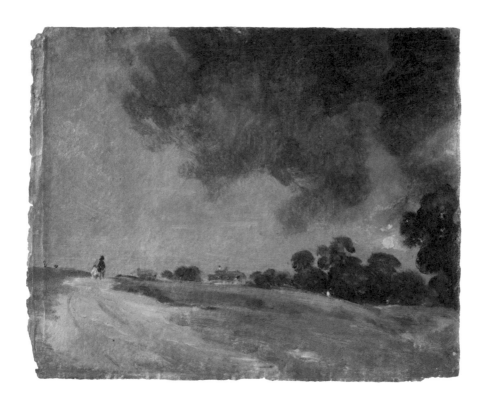

47. *View at Hampstead,*
*Looking Due East,* 1823
Oil on paper, 24.8 × 30.5 cm
(9³⁄₄ × 12 in.)
Inscribed, probably by the artist,
on the back: *Hampstead. Augst 6th 1823*
*Eveng. Looking due East [ward or wind*
deleted], and *Eveg – 6th Augt 1823,*
and inscribed: *J.C.* in monogram.
Victoria and Albert Museum, London
(V&A: 154–1888)

The support of this sketch was pre-prepared with a blue
ground, probably for speed in chasing transient evening light
effects. Here, the warm glow of the sunset illuminates the
couple walking towards the houses on the horizon, while the
rising moon peeps out between the trees and the dark clouds
at the right.

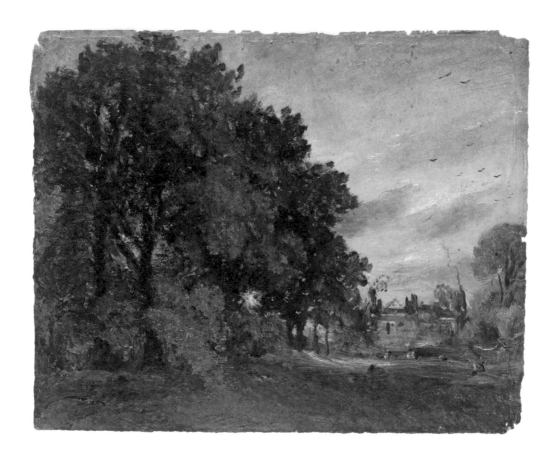

48. *Study of a House amidst Trees: Evening*, 1823
Oil on paper, 25.1 × 30.7 cm
(9⁷⁄₈ × 12¹⁄₈ in.)
Inscribed by the artist on the back: *Saturday Evg 4th Oct 1823*.
Victoria and Albert Museum, London
(V&A: 152–1888)

This sketch was made at dusk on a day that Luke Howard's observations show was cloudy and cool, not exceeding 15°C. Birds hover and chimney smoke wafts vertically in the still air, while the setting sun sparkles through the trees and bathes the lawn before the house in light.

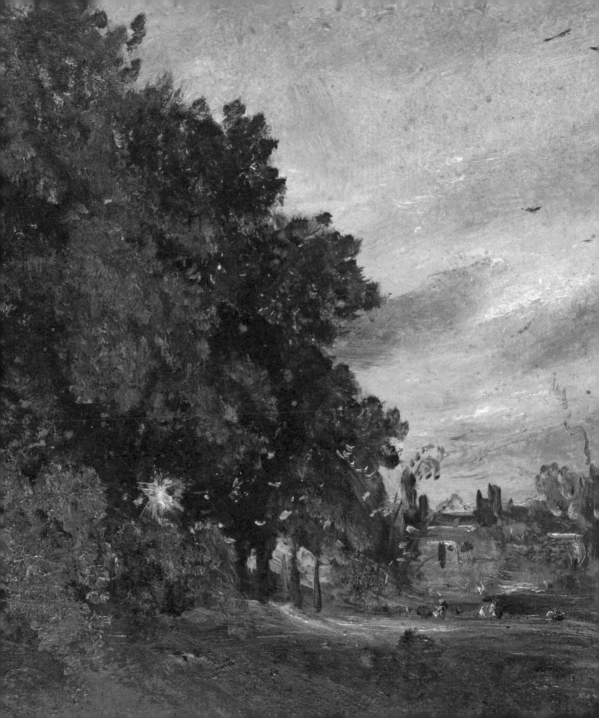

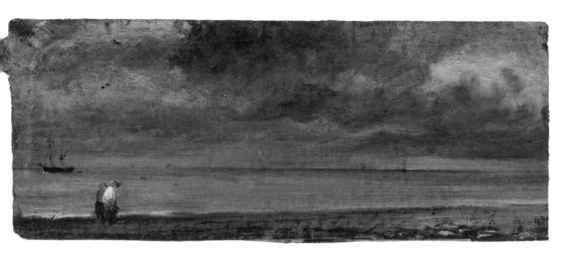

49. *Brighton Beach*, 1824
Oil on paper, 12 × 29.7 cm
(4³/₄ × 11⁵/₈ in.)
Inscribed by the artist on the
back: *June 12 1824 and taking the air*
[struck through] *Squaly* [sic] *day*
Victoria and Albert Museum, London
(V&A: 783–1888)

This remarkably minimalist view uses a long and thin format
to express the expanse of the sea and sky. At the left a boat
travels in the opposite direction from the two women, who
are wearing bonnets against the weather. Their bent backs
suggest the buffeting squall from the sea on this wet and
windy summer's day.

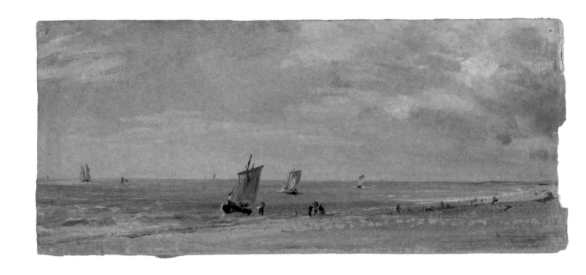

50. *Brighton Beach*, 1824
Oil on paper, 13.6 × 13.2 cm
(5⅞ × 9¾ in.)
Inscribed by the artist on the back:
*Beach Brighton July 19. Noon.*
*1824 my dear Minna's Birthday*
Victoria and Albert Museum, London
(V&A: 148–1888)

Constable disliked Brighton, but admired its 'breakers –
& sky – which have been lovely indeed and always varying'.
The pinkish ground of this sketch shows through in places in
the sky and on the beach. It depicts fishing boats propelled by
the same brisk easterly breeze that disperses the final vestiges
of the dark cloud at the extreme right.

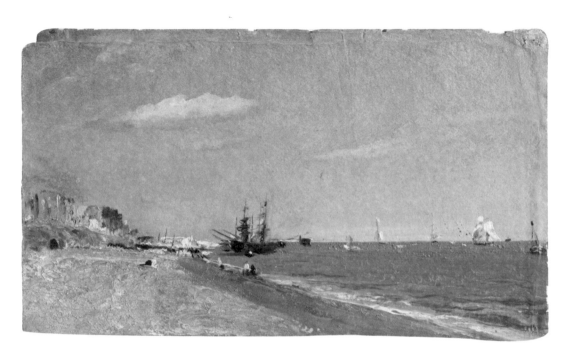

51. *Brighton Beach, with Colliers*, 1824
Oil on paper, 14.9 × 24.8 cm
(5⅞ × 9¾ in.)
Inscribed on the back, probably
by the artist: *3d tide receeding* [sic] *left*
*the beach wet – Head of the Chain Pier*
*Beach Brighton July 19 Evg., 1824 My*
*dear Maria's Birthday Your Goddaughter*
*– Very lovely Evening – looking eastwards*
*– cliffs & light off a dark grey*[?] *effect –*
*background – very white and golden light.*
Victoria and Albert Museum
(V&A: 591–1888)

As Brighton lacked a harbour, the black-hulled colliers had
to be beached to unload. On an almost cloudless evening,
Constable was entranced by the blue sky, the limpid light and
the moist sand left by the ebbing tide. The inscription shows
that this is one of the sketches he lent early in 1825 to his
daughter Maria's godfather John Fisher.

Windmills on the Sussex Downs took advantage of the prevailing south-westerly winds, here blowing the dark clouds to the right. Constable's inscription distinguishes the older pattern of 'smock' mill from the newer brick-built tower mill, depicted here, and suggests that he found such scenery barren in comparison with the highly cultivated Stour valley.

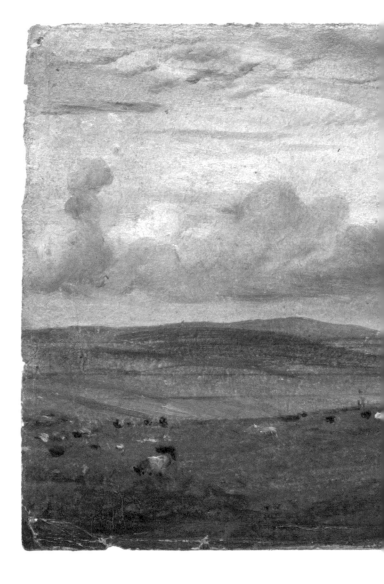

52. *A Windmill near Brighton*, 1824
Oil on paper, 16.1 × 30.7 cm
(6³/₈ × 12¹/₈ in.)
Inscribed by the artist on the back:
*Brighton Augst. 3d 1824 Smock or*
*Tower Mill west end of Brighton the*
*neighbourhood of Brighton – consists of*
*London cow fields – and Hideous masses*
*of unfledged earth called the country.*
Victoria and Albert Museum, London
(V&A: 149–1888)

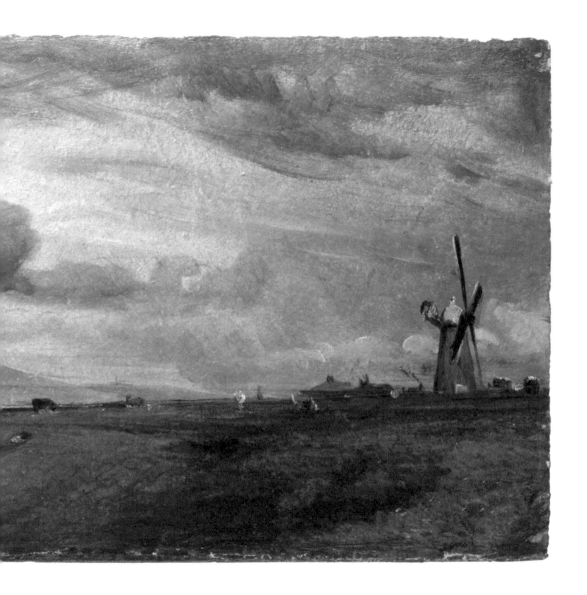

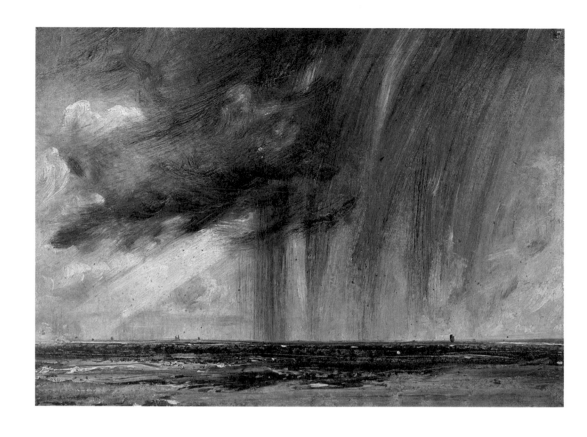

*53. A Rain Storm over the Sea*, 1824/8
Oil on paper, laid on canvas,
22.2 × 31 cm (8³⁄₄ × 12¹⁄₄ in.)
Royal Academy, London
(03/1390)

A low horizon and restricted palette, largely of greyish tones, intensify the drama of this expressive sketch of a violent squall hammering the sea, off Brighton beach. It depicts the downpour released by the dark cumulus cloud; the bright shaft of slanting white sunlight that will warm the sea and cause evaporation; and the pale background towers of cumulus formed as this water vapour condenses, and from which more rain will fall.

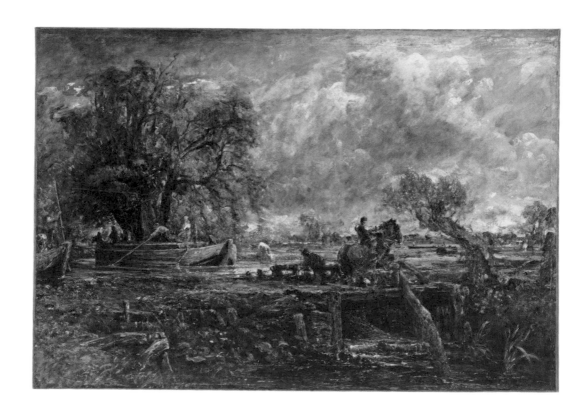

*54. Full-scale Study for*
*'The Leaping Horse',* 1824–5
Oil on canvas, subsequently lined,
129.4 × 188 cm (48 × 72 in.)
Victoria and Albert Museum, London
(V&A: 986–1900)

Constable worked indoors on this full-size study for the large
'set piece' exhibited in 1825. He painted the sky first, leaving
a reserve for the big tree and the horse; later he excised a
standing figure at the left and added the willow at the right.
The top and right margins of the canvas were also opened out
to increase its size. Dark clouds at top left and centre suggest
a coming rain shower, but he later brightened the sky in the
exhibition version.

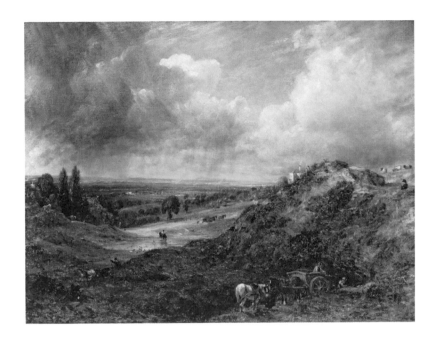

55. *Hampstead Heath:*
*Branch Hill Pond*, 1828
Oil on canvas, 59.6 × 77.6 cm
(23½ × 30½ in.)
Inscribed by the artist on the stretcher:
*No.2 Landscape John Constable 35*
*Charlotte Street Fitzroy Square*
Victoria and Albert Museum, London
(V&A: F.A.35 [O])

Based on a sketch made nine years earlier (*Branch Hill Pond,*
*Hampstead,* 15), this view depicts brighter and more varied
weather, with dark rain clouds encroaching upon the blue sky,
while white cumulus drifts off to the right. A mezzotint of
this scene was published in 1831 with the alternative subtitles
'Storm approaching' and 'Stormy noon'.

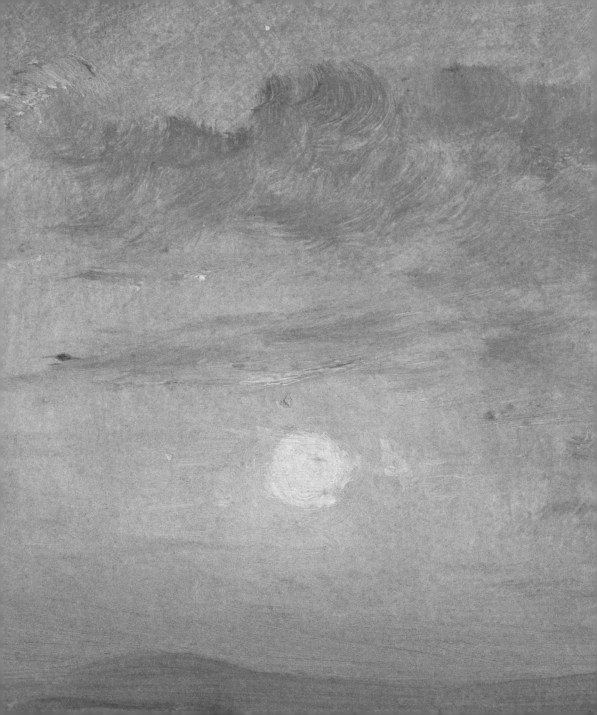

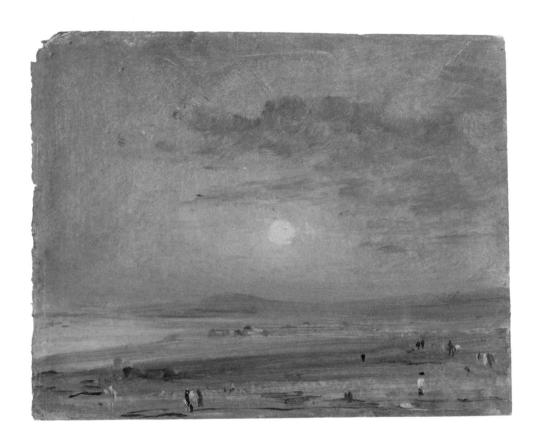

56. *Shoreham Bay*, 1828
Oil on paper, 20 × 24.8 cm
(7⅞ × 9¾ in.)
Inscribed by the artist
on the back: *22 May.*
Victoria and Albert Museum, London
(V&A: 155–1888)

Constable was in Brighton, 11 kilometres (7 miles) east of
Shoreham, during 16–30 May 1828, and this study was most
likely painted around 7.45pm. The artist was fascinated by
sunsets, and here the almost featureless landscape, devoid
of trees and modulating weather effects, focuses attention
on the valedictory golden light of the setting sun and the
complementary purple tones of the sparse clouds and
distant headland.

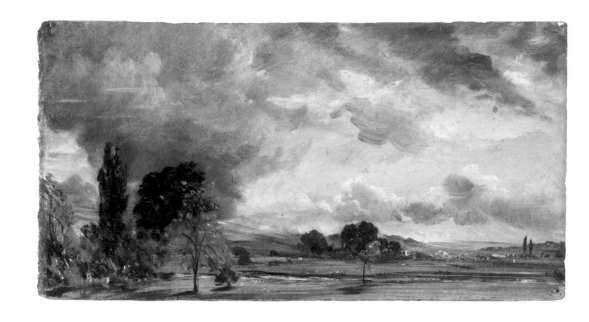

57. *A View of Salisbury from Fisher's Library*, 1829
Oil on paper, 16.2 × 30.5 cm
(6³⁄₈ × 12 in.)
Inscribed by the artist on the back:
*Fisher's – Library – Salisbury Sunday July 12. 1829. 4 0 clock afternoon.*
Victoria and Albert Museum, London
(V&A: 153–1888)

This dramatic sketch was made from the library of John Fisher's residence, Leadenhall. Across the foreground, the silvery strip with white highlights is the River Avon, beyond which water meadows occupy the centre of the scene. At the left a dark rain cloud shrouds the crest of Harnham Ridge, and blue patches pierce the lighter cloud, which extends to the right above the expanse of Salisbury Plain.

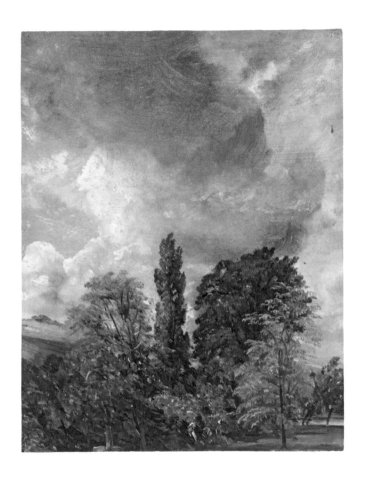

58. *The Close, Salisbury*, 1829
Oil on paper, 26.4 × 20.3 cm
(10³/₈ × 8 in.)
Inscribed on the back: *Close – 15 July –
1829 11.0 clock noon – Wind S.W. – very
fine*, and inscribed: *J. Constable R.A.*
Victoria and Albert Museum, London
(V&A: 334–1888)

The vertical format of this sketch, which was made in the space
of an hour on a fine but windy day, emphasizes the silhouettes
of the tall and slender poplar and the bulbous giant alder.
Towering cloud swirls above the diagonal slope of Harnham
Ridge. The agitated branches of the trees suggest a fresh
breeze is blowing.

This work was made using a half-scale ink sketch, traced through a sheet of glass. Its early subtitle, 'painted from nature', suggests that it was painted out of doors. This airy scene is enlivened by majestic tiers of cloud receding in a placid sky, and the sparkling surface of the flowing river, broken by the reflections of willows. Constable was infuriated when colleagues dismissed this picture as 'a poor thing' and 'very green'.

59. *Watermeadows at Salisbury*, 1829
Oil on canvas, 45.7 × 55.3 cm
(18 × 21¾ in.)
Victoria and Albert Museum, London
(V&A: F.A.38 [o])

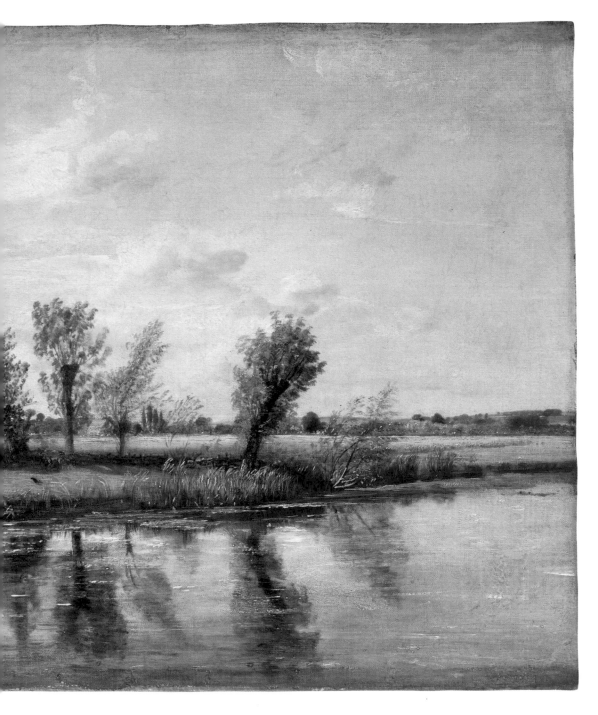

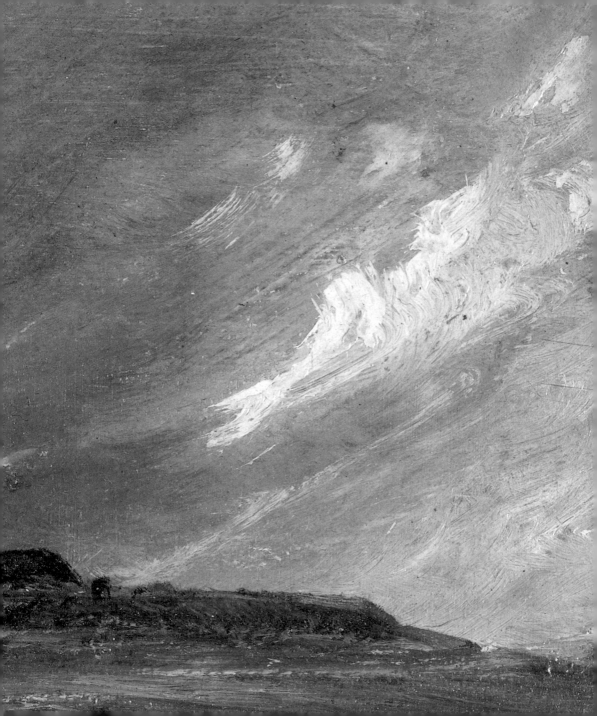

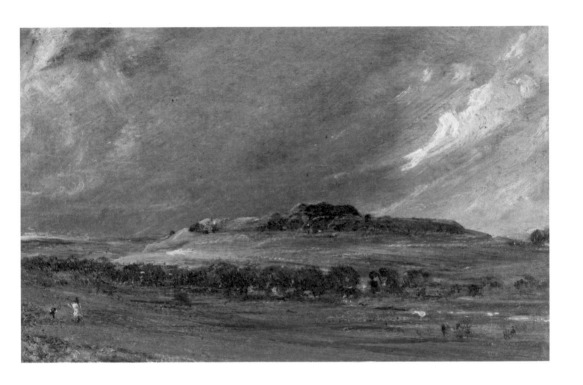

60. *Old Sarum, c.*1829
Oil on card, 14.3 × 21 cm (5⅝ × 8¼ in.)
Victoria and Albert Museum, London
(V&A: 163–1888)

In his commentary on a mezzotint of this sketch, published
in 1833, Constable remarked that its 'awful and impressive'
character was heightened by 'Sudden and abrupt appearances
of light, thunder clouds, wild autumnal evenings, solemn and
shadowy twilights…with variously tinted clouds, dark, cold,
and gray, or ruddy and bright, with transitory gleams of light'.
He later based a watercolour on this sketch (**70**).

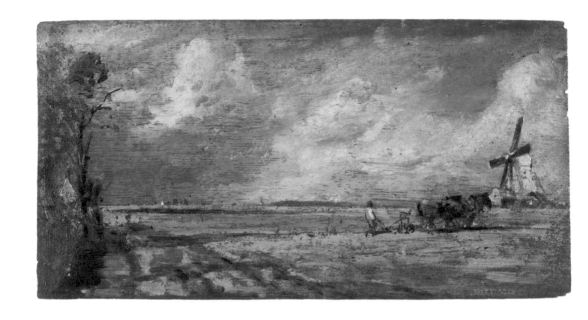

61. *Spring: East Bergholt Common*, *c*.1829
Oil on oak panel, 19 × 36.2 cm
(7½ × 14¼ in.)
Victoria and Albert Museum, London
(V&A: 144–1888)

Based on pencil drawings, one dated 19 April 1821, this lively sketch was probably painted much later in the studio. It provided the model for a mezzotint titled *Spring. A Mill on a Common. Hail Squalls* (62). Constable explained that at this time of year 'the clouds accumulate in very large and dense masses' and faster moving 'isolated pieces…called by wind-millers and sailors "messengers," being always the forerunners of bad weather'.

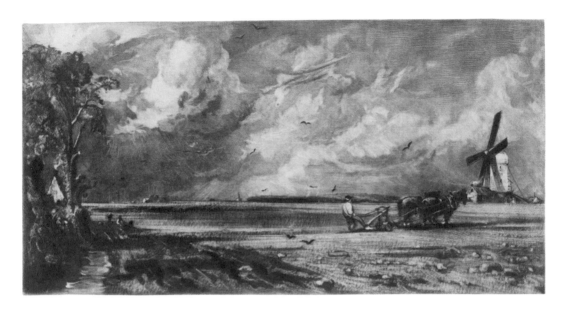

62. David Lucas after John Constable,
*Spring*, this state dated 1832;
published in *English Landscape
Scenery, Part One*, 1833
Mezzotint, 15.5 × 25.5 cm (6⅛ × 10 in.)
Victoria and Albert Museum, London
(V&A: E.2381–1901)

Constable commented on this mezzotint:

> This plate may perhaps give some idea of one of those
> bright and animated days of the early year, when all
> nature bears so exhilarated an aspect; when at noon
> large garish clouds, surcharged with hail or sleet, sweep
> with their broad cool shadows the fields, woods and
> hills;…heightening also their brightness, and by their
> motion causing that playful change so much desired
> by the painter.[76]

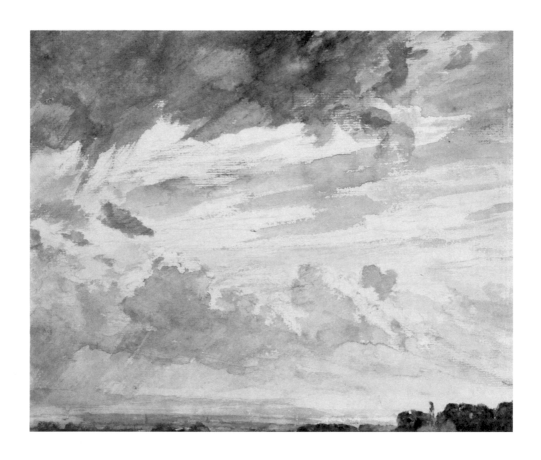

63. *Study of Clouds above
a Wide Landscape*, 1830
Pencil and watercolour,
19 × 22.8 cm (7½ × 9 in.)
Inscribed by the artist on
the back: *about 11 – noon –
Sepr 15 1830. Wind – W.*
Victoria and Albert Museum, London
(V&A: 240–1888)

A sketch made from a south-facing window in Constable's house at Hampstead. Howard's observations record that the day was warm and fine with a westerly breeze and a temperature around 18°C. Patches of blue sky show through streaks of white cirrus, while a dark cumulus cloud dominates the top of the view.

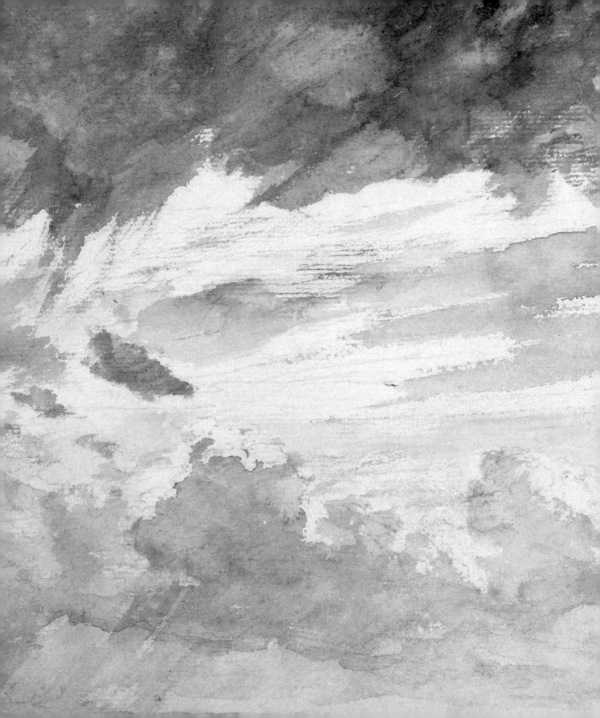

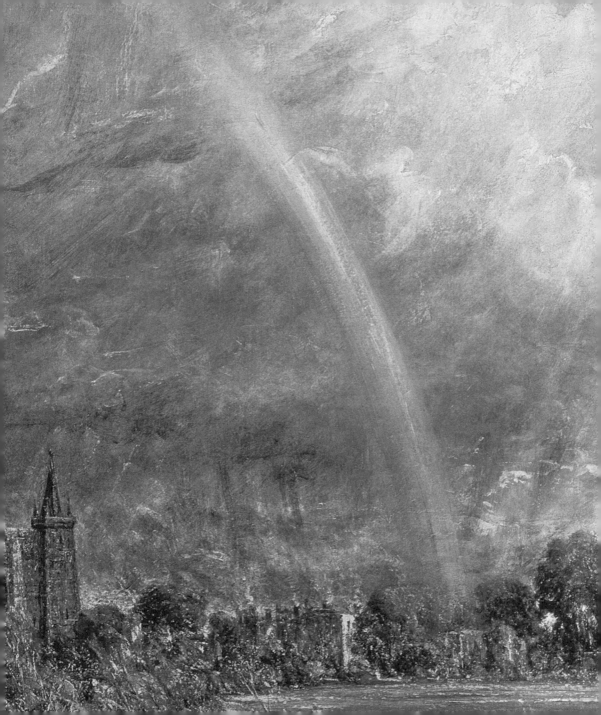

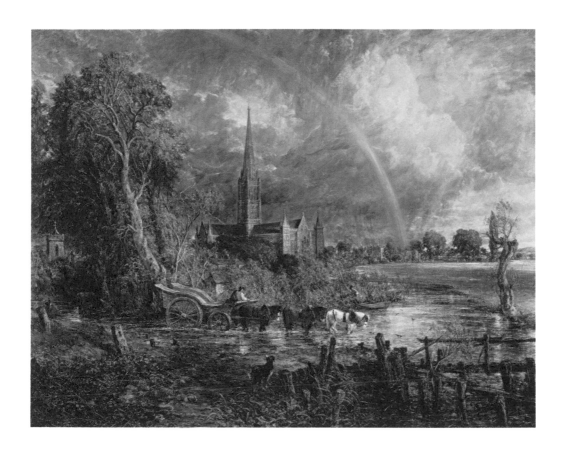

64. *Salisbury Cathedral*
*from the Meadows*, 1831
Oil on canvas, 151.8 × 189.9 cm
(59³⁄₄ × 74³⁄₄ in.)
Tate
(T13896)

Based on a drawing made in 1829, this painting was first
exhibited in 1831. The rainbow was probably added in 1834 to
commemorate Constable's friend John Fisher. At the time of
Fisher's death in August 1832 a rainbow could have occupied
the location where it is depicted, but would not have been
visible from this viewpoint with light falling from the right,
as shown. This picture was exhibited again in 1836, with the
added subtitle *Summer Afternoon – A Retiring Tempest*.

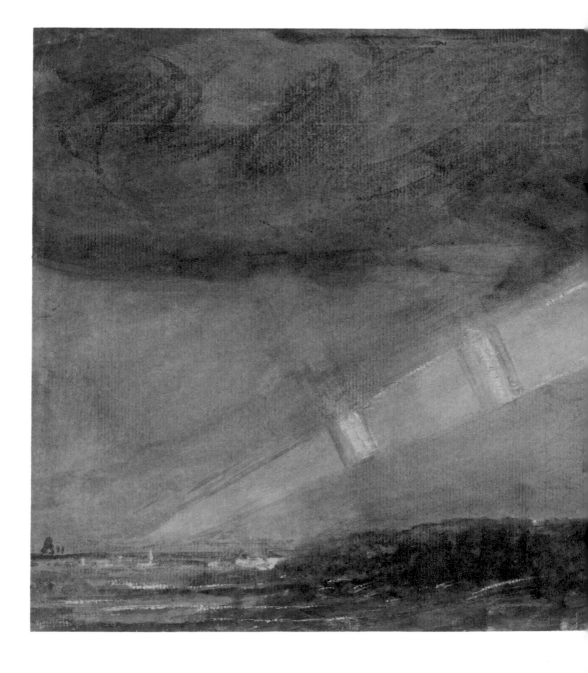

This sketch demonstrates an extensive knowledge of meteorological effects. The segments of the primary and secondary bows of a rainbow are depicted at their proper scale and relationship, with the latter's colours reversed. Constable may have been the first painter to depict the converging rays of sunlight, most often seen at sunrise or sunset, here piercing the purple clouds to reveal the double rainbow: a rare phenomenon called 'a rainbow wheel'. The silhouette of St Paul's appears on the horizon at the bottom left.

65. *London from Hampstead, with a Double Rainbow*, 1831
Watercolour, 19.6 × 32 cm
(7³⁄₄ × 12⁵⁄₈ in.)
Inscribed by the artist on the back: *between 6. & 7.o clock/Evening June 1831*
British Museum, London
(1888,0215.55)

66. John Constable, after Jacob
van Ruisdael, *Winter*, 1832
Oil on canvas, 58.1 × 71.8 cm
(22⁷/₈ × 27⁷/₈ in.)
Inscribed by the artist on the back:
*Copied from the Original Picture by*
*Ruisdael in the possession of Sir Robt Peel,*
*Bart. By me John Constable R.A. at Hampd*
*Sep. 1832 P.S. Color…Dog added…only…*
*Size of the Original…and Showed this*
*Picture to Dear John Dunthorne Octr 30*
*1832…this was the last time I…poor J*
*Dunthorne died on friday (all Saints) the*
*2d of November. 1832 – at 4 0 clock in*
*the afternoon Aged 34. years*
Private collection

Constable made such exact 'facsimiles' to attain a closer
understanding of works he admired. This is a copy of a
painting owned by Sir Robert Peel. Constable used it as a
visual aid during a lecture in 1836 to demonstrate the Dutch
master's expert knowledge of weather, observing: 'Ruysdael
*understood* what he was painting.' He associated its wintry
subject with the recent deaths of his friends John Fisher
and John Dunthorne.

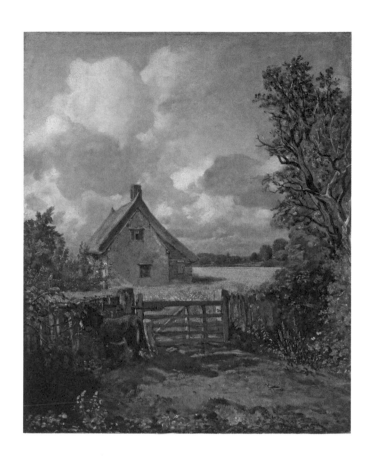

*67. The Cottage in a Cornfield, 1833*
Oil on canvas, 62 × 51.5 cm
(24½ × 20¼ in.)
Victoria and Albert Museum, London
(V&A: 1631–1888)

Using a pencil sketch made at East Bergholt, Constable painted a smaller version of this subject in 1817. The meteorologist L.C.W. Bonacina was profoundly impressed by the artist's dynamic representation of the sky, of which he remarked in 1937: 'we find a still scene of fierce noon-day heat in July or August, and get a powerful impression of fast growing cumulus clouds. That lonely cottage by the ripening corn will hardly escape a crashing storm that afternoon!'

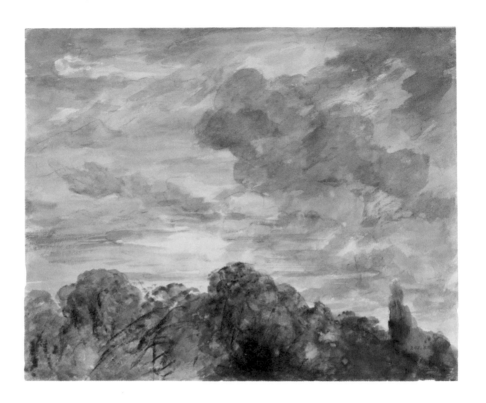

68. *Study of Sky and Trees*, 1833
Pencil and watercolour,
18.6 × 22.9 cm (7³/₈ × 9 in.)
Inscribed by the artist on the
back: *26 Sepr 1833 12 to 1 –*
*noon looking North East.*
Victoria and Albert Museum, London
(V&A: 202–1888)

Above the trees near his house in Hampstead, Constable
correctly observed the darkest cloud bases overhead, with white
clouds interspersed with patches of blue sky. The Meteorological
Journal of Charles Henry Adams, published in *The London
Literary Gazette*, records that at Edmonton, some 9 kilometres
(5½ miles) to the north-east, the weather was cloudy but dry
with a northerly wind and temperatures exceeding 18°C.

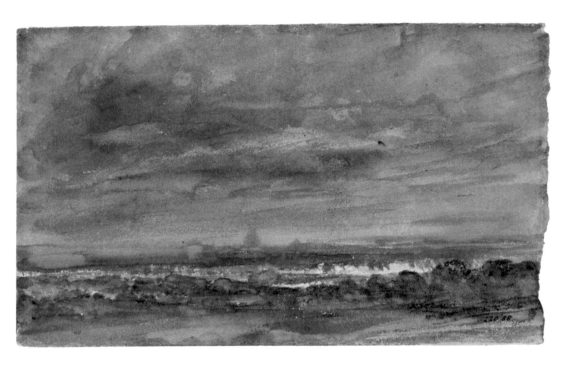

69. *View at Hampstead Looking towards London*, 1833
Watercolour, 11.5 × 19 cm
(4½ × 7½ in.)
Inscribed by the artist on the back:
*Hampd December 7, 1833 3 oclock – very stormy afternoon – & High Wind.*
Victoria and Albert Museum, London
(V&A: 220–1888)

In this sketch made from Constable's house at Well Walk, the view he had praised to a friend as 'unequalled in Europe' is obscured by thick cloud, with the dome of St Paul's barely visible. At Edmonton the weather was recorded as also cloudy with frequent rain and a south-westerly wind, but high temperatures for the season, rising above 12°C.

Owing to illness, Constable was unable to complete an oil painting for exhibition in 1834. He submitted instead this large watercolour, based on an oil sketch made in about 1829 (60). Dark clouds swirl over the medieval ruins, but the sky is brightening at the left. The artist has added a strip of paper at the right to introduce the base of a rainbow, showing that the storm has passed.

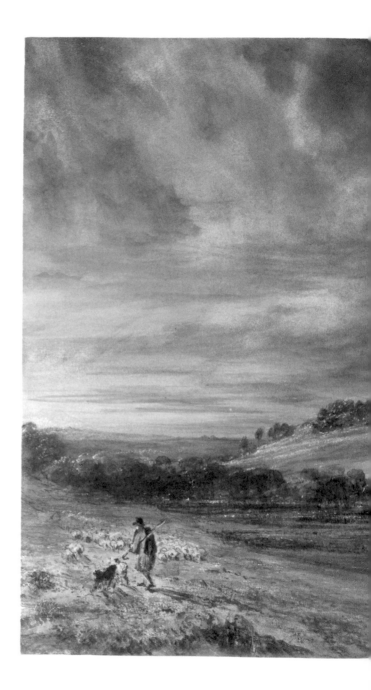

70. *Old Sarum*, 1834
Watercolour, 30 × 48.7 cm
(11³/₄ × 19¹/₈ in.)
Victoria and Albert Museum, London
(V&A: 1628–1888)

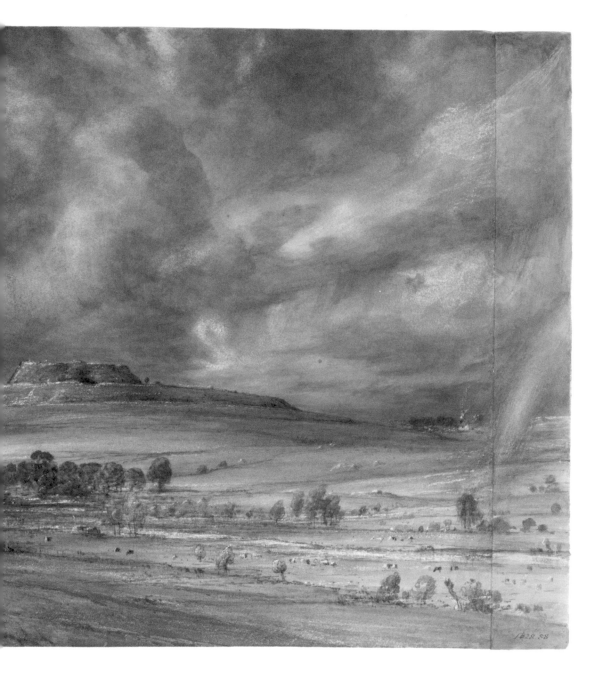

1828.98

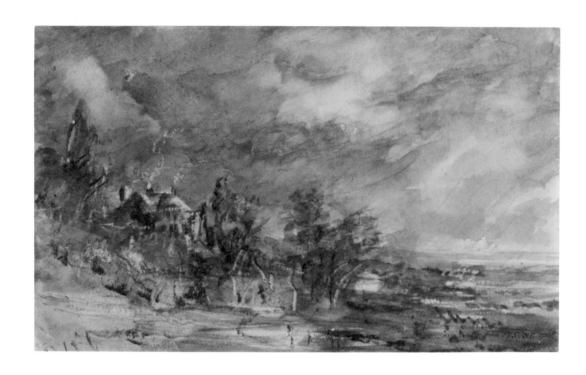

71. *Hampstead Heath,
from near Well Walk*, 1834
Watercolour, 11.1 × 18 cm
(4³/₈ × 7¹/₈ in.)
Inscribed by the artist on
the back: *Spring Clouds – Hail
Squalls – April 12. 1834 –
Noon Well Walk*
Victoria and Albert Museum, London
(V&A: 175–1888)

This dynamic sketch suggests exultation at the storm
agitating the trees and chimney smoke near Constable's house.
By saturating his support and scraping its damp surface to
expose the white underlying paper, he achieved expressive
effects of driving rain and glistening wetness. That spring
day in Edmonton there was frequent hail with a heavy shower
about 3pm, a biting south-westerly wind, and temperatures
below 6.7°C.

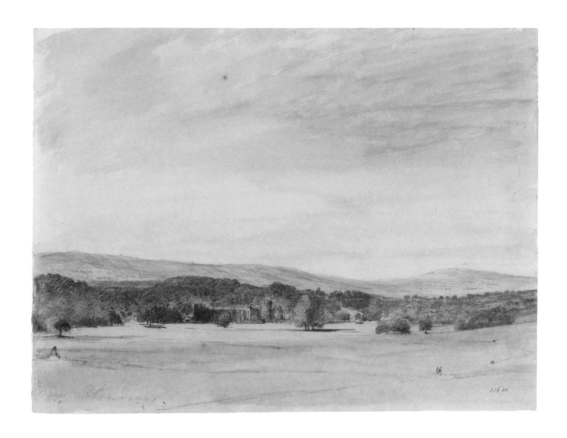

72. *Cowdray Park*, 1834
Pencil and watercolour,
20.7 × 27.2 cm (8⅛ × 10¾ in.)
Victoria and Albert Museum, London
(V&A: 216–1888)

In September 1834 Constable visited Petworth House in
Sussex, the residence of Lord Egremont, whose art collection
included numerous landscapes by Turner and works by the
old masters. This is the most finished of nine pencil and
watercolour studies made on 14 September during an excursion
to the nearby ruins of Cowdray House. The immense open
sky towering over this panorama of the South Downs is
reminiscent of the extensive landscapes by the Dutch
painter Philips Koninck (1619–1688).

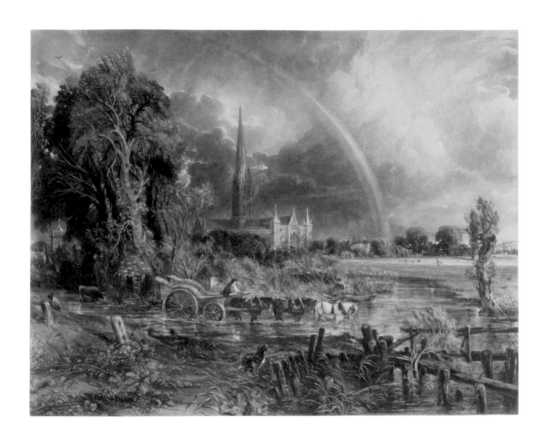

73. David Lucas after John Constable, *Salisbury Cathedral: The Rainbow* (unique progress proof 'e'), *c.*1835 Mezzotint touched with white chalk and wash, 61 × 74.1 cm (24 × 29⅛ in.) Victoria and Albert Museum, London (V&A: 1250–1888)

This unique progress proof after *Salisbury Cathedral from the Meadows* (64), made to check how the mezzotint print looked while work on it was still under way, bears Constable's own amendments. On 6 September 1835 he cautioned his engraver Lucas about the rainbow: 'If it is not exquisitely done – if it is not tender, and elegant – evanescent and lovely, the highest degree – we are both ruined. I am led to this having been very busy with rainbows – and very happy in doing them.'

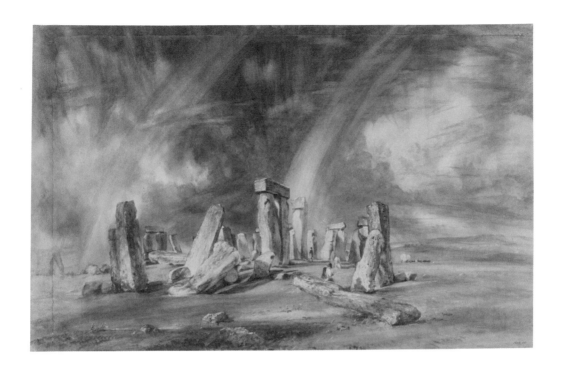

74. *Stonehenge*, 1836
Watercolour, 38.7 × 59.1 cm
(15¼ × 23¼ in.)
Victoria and Albert Museum, London
(V&A: 1629–1888)

During his only known visit to Stonehenge, in July 1820, Constable made pencil drawings, and later he made intermediate studies for this large exhibition watercolour. A reviewer thought its startling atmospheric effects of a blue sky rent by a dark storm cloud and a double rainbow 'as marvellous and mysterious as the subject itself'. The artist enlarged the sheet with strips of paper at the left and top, and enriched the scene with a tiny racing hare, on a separate piece of paper stuck on at bottom left.

75. *A House, Cottage and Trees:*
*perhaps Golding Constable's*
*House by Moonlight, c.*1836
Sepia and grey wash,
18.7 × 22.8 cm (7⅜ × 9 in.)
Victoria and Albert Museum, London
(V&A: 248–1888)

Towards the end of his life, Constable made several spontaneous and expressive sepia sketches in a blot-like technique like that advocated by Alexander Cozens (1717–1786), as a means of 'producing accidental forms without lines, from which ideas are presented to the mind'. Silhouetted against a cloudy sky by a low moon, this view of a cottage, a poplar tree and a rectangular building resembling Constable's parental home, left years earlier by his family, has a distinctly valedictory air.

# Notes

1  Letter to John Fisher, 19 October 1823, in Beckett 1962–8, vol. VI, *The Fishers*, p. 139. The 'bridal picture' is now at the Henry E. Huntington Library and Art Gallery, San Marino, California (R.23.2).

2  Peter R. Cockrell, 'The Meteorological Society of London 1823–1873', *Weather*, vol. 23, no. 9 (September 1968), pp. 357–61; Malcolm Walker, 'James George Tatem, William Henry White and Early Meteorological Societies in Great Britain', *Royal Meteorological Society, Occasional Papers on Meteorological History*, no. 18 (January 2016), pp. 6–8; https://www.rmets.org/sites/default/files/hist18.pdf, accessed 29 September 2017.

3  Badt 1950, pp. 9–22; Thornes 1999, pp. 36–7, 66, 188–91; Morris 2000, p. 122.

4  Walker (cited note 2), pp. 13, 16–18; Charles Henry Adams, 'Meteorological Journal', *The London Literary Gazette*, no. 872 (5 October 1833), p. 638, no. 883 (21 December 1833), p. 813, and no. 901 (26 April 1834), p. 301.

5  Thornes 1999, pp. 19, 39, 68–78; Morris 2000, p. 122.

6  Beckett 1970, p. 64.

7  Thornes 1999, pp. 68–80.

8  Letter to George Constable, 12 December 1836, in Beckett 1962–8, vol. V, *Various Friends, with Charles Boner and the Artist's Children*, p. 36.

9  C.R. Leslie's account of Constable's lecture, 16 June 1836, in Beckett 1970, p. 69.

10  Natural philosophy still retained links with the 'Natural Theology' of clergymen such as William Paley (1743–1805), whose sermons were recommended to the artist by Archdeacon John Fisher (1788–1832). In 1825 Fisher sent Constable a set of Paley's *Sermons on Various Subjects*; letter to Constable, 8 April 1825, in Beckett 1962–8, vol. VI, p. 196; Evans 2017, pp. 111–31 (125–8).

11  Judy Egerton, *Wright of Derby* (Tate Gallery, exhib. cat., London 1990), pp. 58–61; Robert Fox, 'Garnett, Thomas (1766–1802)', *Oxford Dictionary of National Biography* (Oxford 2004); online edn, Jan 2015, http://www.oxforddnb.com/view/article/10395, accessed 23 August 2017.

12  Parris and Shields 1975, pp. 25–52 (44–5).

13  Letter to John Dunthorne, 29 May 1802, in Beckett 1962–8, vol. II, *Early Friends and Maria Bicknell (Mrs Constable)*, p. 32; Parris and Shields 1975, pp. 44–5.

14  Parris and Shields 1975, pp. 30, 45; John Gage, 'A Romantic Colourman: George Field and British Art', in *The Sixty-third Volume of the Walpole Society* (London 2001), pp. 1–73 (17–18).

15  William Paley, *Natural Theology: or, Evidences of the Existence and Attributes of the Deity*, chapter XXI, 'Of the Elements', 12th edn (London 1809), pp. 368–77 (370).

16  Thomas Garnett, *Outlines of a Course of Lectures on Chemistry*, lecture IX, 'Analysis of the atmosphere, and the chemical nomenclature' (Liverpool 1797), pp. 50–4.

17  Evans et al. 2014, p. 19.

18  William Hogarth, *The Analysis of Beauty*, ed. Ronald Paulson (New Haven and London 1997), p. 38; quoted in Evans et al. 2014, p. 19.

19  Jean-Baptiste Dubos, *Critical Reflections on Poetry, Painting and Music* (London 1748), vol. 2, pp. 218–19; quoted in Evans et al. 2014, pp. 17–18.

20  George Field, *Chromatography; or, a Treatise on Colours and Pigments, and of their Powers in Painting*, Chapter IV: 'On the Physical Causes of Colours' (London 1835), pp. 34–43 (35).

21  Wien 2016, pp. 155–75 (169–74). The title of the 1833 edition of Lucas's mezzotints after Constable's designs states that it was 'principally intended to mark the Phenomena of the Chiar' Oscuro of Nature'; Wilton 1979, pp. 7–8. Lecture, 9 June 1836, in Beckett 1970, p. 62.

22  Kenneth Garlick, Angus Macintyre, Kathryn Cave and Evelyn Newby (eds.), *The Diary of Joseph Farington*, vol. V (New Haven and London 1979), p. 1,764.

23  Letter to John Dunthorne, 29 May 1802, in Beckett 1962–8, vol. II, pp. 31–2.

24  Evans et al. 2014, pp. 46, 60–1.

25 Ibid., pp. 17–18.

26 Thornes 1999, pp. 96–7.

27 Leslie 1951, p. 14; Thornes 1999, p. 96; Evans et al. 2011, p. 18.

28 Cornelius Varley (1781–1842), quoted by Timothy Wilcox, 'The Art of Cornelius Varley', in *Cornelius Varley: The Art of Observation* (exhib. cat., Lowell Libson, London 2005), pp. 9–18 (10–11).

29 Leslie 1951, pp. 5–6.

30 Ibid., p. 18; Hebron et al. 2006.

31 Lecture, 9 June 1836, in Beckett 1970, p. 61.

32 Evans et al. 2014, pp. 23–5, 32–3, 156, 170–1.

33 John Gage, 'Clouds over Europe', in Morris 2000, pp. 125–34 (129).

34 Constable's interest in van de Velde is shown by his pencil copies of the Dutch master's painting *A Sea Calm*, lent by the Royal Collection to the British Institution in 1819, and another sea piece attributed to the same artist, the copy of which is dated 13 July 1819 (R.19.18A, 19.18B); Anne Lyles, '"That immense canopy": Studies of Sky and Cloud by British Artists *c.*1770–1860', in Morris 2000, pp. 135–50 (139); and Anne Lyles, '"The glorious pageantry of Heaven": an assessment of the motives behind Constable's "skying"', in Bancroft 2004, pp. 29–54.

35 R.19.11–16.

36 Thornes 1999, pp. 118–19.

37 *The Examiner* (27 May 1821); Ivy 1991, p. 88.

38 Anonymous reviews in *The Literary Gazette* (2 June 1821) and *Repository of Arts* (June 1821); Ivy 1991, pp. 89–90.

39 Letter, 21 October 1821, in Beckett 1962–8, vol. VI, p. 76.

40 Ibid., pp. 76–7.

41 Thornes 1999, p. 122.

42 Ibid., pp. 122–3.

43 Louis Hawes, 'Constable's sky sketches', *Journal of the Warburg and Courtauld Institutes*, vol. 32 (1969), pp. 344–65 (360, n. 61).

44 Letter from John Fisher, 3 January 1821, in Beckett 1962–8, vol. VI, p. 60.

45 Letter from John Fisher, 16 October 1823, in Beckett 1962–8, vol. VI, p. 138; Timothy Wilcox, *Constable and Salisbury: The Soul of Landscape* (exhib. cat., London 2011), pp. 86–109.

46 R.23.55–74; Evans et al. 2014, pp. 111, 119.

47 Letter, 29 August 1824, in Beckett 1962–8, vol. VI, p. 171.

48 See Constable's account of 'A Sea-Beach – Brighton' from part two of his mezzotint series, published in 1830; Wilton 1979, pp. 42–4.

49 Letter from John Fisher, 8 April 1825, in Beckett 1962–8, vol. VI, p. 196.

50 Letter to John Fisher, 17 November 1824, in Beckett 1962–8, vol. VI, p. 181.

51 Undated letter to John Fisher, April 1825, in Beckett 1962–8, vol. VI, p. 198.

52 Anonymous review in *The Sun*, 5 May 1828; Ivy 1991, p. 127.

53 R.28.4.

54 Letter to Maria Constable, 23 November 1825, in Beckett 1962–8, vol. II, p. 411.

55 Wilcox (cited note 45), pp. 113–31.

56 Evans et al. 2014, pp. 53–4, 79.

57 Letters from John Fisher, 9 August 1829, in Beckett 1962–8, vol. VI, pp. 250–1.

58 Letters of 1 October 1822 and 1 January 1825, in Beckett 1962–8, vol. VI, pp. 95, 188.

59 Wilton 1979, pp. 42–4; Stephen Calloway, 'Canon: "the Chiar'Oscuro of Nature"', in Evans et al. 2014, pp. 183–207.

60 Wien 2016, pp. 173–5.

61 Wilton 1979, pp. 32, 38.

62 Gage (cited note 14), pp. 17–18.

63 Wilcox (cited note 45), pp. 135–57; Evans et al. 2014, pp. 161–2, 176–7.

64 Thornes 2017.

65 Evans et al. 2014, pp. 115, 161–2, 176–7. Undated letter, after 25 August 1832, in Beckett 1962–8, vol. III, *C.R. Leslie, R.A.*, pp. 79–80.

66 R.17.2.

67 Thornes 1999, pp. 109–11, 145.

68 R.29.1.

69 R.36.1.

70 Reynolds 1965, p. 132, likening the style of the oil painting *The Cenotaph* (R.36.1) to watercolours such as *Stonehenge* (74).

71 R.10.4; 10.5.

72 R.22.18.

73 R.22.25.

74 R.22.27.

75 R.20.50.

76 The title of the introduction to this book, 'The natural history of the skies above', is a quotation from this commentary: 'The natural history – if the expression may be used – of the skies above alluded to…is this.'

## References to Works Illustrated

Unless otherwise noted, all works reproduced in this book were given by Isabel Constable to the Victoria and Albert Museum, London. Other works in the V&A's collection are nos 19 and 54 (bequeathed by Henry Vaughan); and 45, 46, 55 and 59 (given by John Sheepshanks). The other works are reproduced by kind permission of: akg-images/Erich Lessing: 38; Ashmolean Museum, University of Oxford/ Bridgeman Images: 43; Bridgeman Images: 64; Trustees of the British Museum, London: 65; The Samuel Courtauld Trust, The Courtauld Gallery, London: 42; National Gallery of Victoria, Melbourne, Australia/Fulton Bequest, 1938/Bridgeman Images: 39; Private Collection: 6, 16, 22, 24, 41, 44; Private Collection: 66; Royal Academy of Arts, London/Bridgeman Images: 53; Yale Center for British Art, Paul Mellon Collection, USA/Bridgeman Images: 26.

Unless otherwise stated, all works are by John Constable.

The current locations of the works, and their inventory or accession numbers, are given in the captions. The following abbreviations are used in the list below of the key references to these works in the secondary literature. (R numbers are also used in the notes to refer to works by Constable not reproduced in this book.)

R   The listing of the work in Constable's catalogue raisonné by Graham Reynolds: *The Later Paintings and Drawings of John Constable*, 2 vols (New Haven and London 1984), for nos 17.1–37.7; and *The Early Paintings and Drawings of John Constable*, 2 vols (New Haven and London 1996), for nos 90.1–16.111 and Additions 17.29A–36.36

LH   References in Luke Howard, *The Climate of London*, 2nd edn, vol. 3 (London 1833)

LLG   References in the 'Meteorological Journal' by Charles Henry Adams, in *The London Literary Gazette*, no. 872 (5 October 1833), p. 638; no. 883 (21 December 1833), p. 813; no. 901 (26 April 1834), p. 301

T   Page references or appendix numbers in John E. Thornes, *Constable's Skies* (Birmingham 1999)

T2   John E. Thornes, 'A Reassessment of the Solar Geometry of Constable's Salisbury Rainbow', in Amy Concannon (ed.), *In Focus: Salisbury Cathedral from the Meadows exhibited 1831 by John Constable* (Tate Research Publication 2017), http://www.tate.org.uk/research/publications/

in-focus/salisbury-cathedral-constable/reassessing-the-rainbow, accessed 29 September 2017

L   Page or catalogue numbers in Edward Morris (ed.), *Constable's Clouds: Paintings and Cloud Studies by John Constable* (Walker Art Gallery, Liverpool, and National Gallery of Scotland, Edinburgh, exhib. cat., 2000)

S   Page or catalogue number in Frederic Bancroft (ed.), *Constable's Skies* (Salander-O'Reilly Galleries, exhib. cat., New York, 2004)

E1 and E2

Page or catalogue numbers in Mark Evans, *John Constable: Oil Sketches from the Victoria and Albert Museum* (V&A, exhib. cat., London 2011) and Mark Evans, *John Constable: The Making of a Master* (V&A, exhib. cat., London 2014)

1   R.02.6; E1, no. 1; E2, no. 28
2   R.02.7; T, pp. 96–7; E1, no. 2; E2, no. 10
3   R.05.22
4   R.06.204; T, pp. 99–100
5   R.09.65; L, no. 1; E1, no. 11; E2, no. 34
6   R.09.66; T, pp. 102–3; S, p. 147
7   R.11.9; E1, no. 12; E2, no. 35
8   R.11.32; L, no. 8; E2, no. 38
9   R.12.2; E1, no. 15; E2, no. 154
10   R.12.25; T, p. 103; E1, no. 19
11   R.12.51; E1, no. 20; E2, no. 156
12   R.12.29; T, pp. 103–5; E1, no. 21; E2, no. 138
13   R.12.50; L, no. 15; E1, no. 18; E2, no. 151
14   R.16.78; L, no. 25; E2, no. 39
15   R.19.32; T, p. 114; E1, no. 30; E2, no. 119
16   R.20.37; T, pp. 175–6; L, no. 29; S, no. 5
17   R.20.77; T, no. 1
18   R.20.82; T, no. 4

19  R.21.2; T, pp. 118–21; E1, no. 37; E2, no. 103
20  R.21.45; T, no. 11
21  R.21.112
22  R.21.46; T, no. 13; L, no. 36; S, no. 16
23  R.21.48; T, no. 15; E1, no. 40
24  R.21.49; T, no. 16; L, no. 38; S, no. 6
25  R.21.51; T, no. 18; E1, no. 41
26  R. 21.57; T, no. 23
27  R.21.58; T, no. 24; L, no. 41
28  R.21.61; T, no. 27
29  R.21.66; T, no. 30
30  R.22.43; E1, no. 45; E2, no. 41
31  R.22.44; L, no. 60; E1, no. 46; E2, no. 42
32  R.22.56; S, no. 22
33  R.22.59; T, pp. 122–3; L, no. 56; S, pp. 44–5; E1, no. 44; E2, no. 44
34  R.22.6; L, no. 43; E2, no. 55
35  R.22.13; T, no. 36; E1, no. 46
36  R.22.14; T, pp. 75–6, no. 37; L, no. 49
37  R.22.15; T, no. 38; L, no. 49; E1, no. 48
38  R.22.21; T, no. 46; L, no. 52
39  R.22.23; T, no. 48
40  R.22.24; T, no. 49; E2, no. 43
41  R.22.26; T, no. 50; L, no. 55
42  R.22.28; T, no 53; L, no. 57
43  R.22.30; T, no. 54; L, no. 58; S, no. 21
44  R.22.55; L, no. 54; S, no. 24
45  R.21.10; E2, no. 53
46  R.23.1; T, pp. 126–8; E1, pp. 22–3; E2, no. 110
47  R.23.14; E1, no. 49
48  R.23.23; LH, p. 126, table CCIX; E1, no. 50
49  R.24.9; E1, no. 65; E2, no. 45
50  R.24.10; L, no. 64; E1, no. 66
51  R.24.11; T, pp. 128–9; L, no. 65; E2, no. 46
52  R.24.17; E1, no. 68; E2, no. 48
53  R.24.67; T, pp. 128–9; L, no. 66; E2, no. 47
54  R.25.2; L, pp. 102–3; E1, no. 38; E2, no. 106
55  R.28.2; E1, no. 31; E2, no. 120
56  R.28.7; L, no. 68
57  R.29.14; L, no. 74
58  R.29.15; T, pp. 58–9; L, no. 76; E1, no. 58; E2, no. 49
59  R.29.41; L, no. 32; E2, pp. 53–4, no. 57
60  R.29.65; E1, no. 60; E2, no. 111
61  R.21.13; E1, no. 24; E2, no. 145
62  E2, no. 146
63  R.30.11; LH, p. 364, table CCXCII; E1, no. 53
64  R.31.1; T, pp. 81–4, 141–3; T2; L, no. 77; E2, no. 133
65  R.31.7; T, pp. 88, 142–4; T2, pp. 11–12
66  R.32.43; E2, p. 115 and 126, no. 93
67  R.33.3; T, pp. 109–11, 145; E2, no. 162
68  R.33.20; LLG, no. 872 p. 638
69  R.33.32; LLG, no. 883 p. 813; E1, no. 54
70  R.34.1; T, pp. 145–6; E1, pp. 32–3; E2, no. 112
71  R.34.6; LLG, no. 901 p. 301; E1, no. 55
72  R.34.39; T, pp. 175–6
73  T, pp. 147; E2, no. 167
74  R.36.3; T, pp. 146–7; E2, no. 136
75  R.36.30.

# Selected Bibliography

Kurt Badt, *John Constable's Clouds* (London 1950)

Frederic Bancroft (ed.), *Constable's Skies* (Salander-O'Reilly Galleries, exhib. cat., New York 2004)

R.B. Beckett (ed.), *John Constable's Correspondence*, 6 vols, Suffolk Records Society vols 4, 6, 8, 10, 11, 12 (London and Ipswich 1962–8)

R.B. Beckett (ed.), *John Constable's Discourses* (Ipswich 1970)

Jonathan Clarkson, *Constable* (London and New York 2010)

Mark Evans, '"Full of vigour, & nature, fresh, original, warm from observation of nature, hasty, unpolished, untouched": The Oil Sketches of John Constable', in Toshiharu Nakamura (ed.), *Appreciating the Traces of an Artist's Hand, Kyoto Studies in Art History*, vol. 2 (2017), pp. 111–31 (125–8)

Mark Evans with Nicola Costaras and Clare Richardson, *John Constable: Oil Sketches from the Victoria and Albert Museum* (Victoria and Albert Museum, exhib. cat., London 2011)

Mark Evans, Clare Richardson and Nicola Costaras, 'A recently discovered oil-sketch by John Constable at the Victoria and Albert Museum', *The Burlington Magazine*, CLV, no. 1329 (December 2013), pp. 823–6

Mark Evans with Stephen Calloway and Susan Owens, *John Constable: The Making of a Master* (Victoria and Albert Museum, exhib. cat., London 2014)

Ian Fleming-Williams and Leslie Parris, *The Discovery of Constable* (London 1984)

Ian Fleming-Williams and Leslie Parris, *Constable* (Tate Gallery, exhib. cat., London 1991)

Ian Fleming-Williams, Leslie Parris and Conal Shields, *Constable: Paintings, Watercolours and Drawings* (Tate Gallery, exhib. cat., London 1976)

Louis Hawes, 'Constable's sky sketches', *Journal of the Warburg and Courtauld Institutes*, vol. 32 (1969), pp. 344–65

Stephen Hebron, Conal Shields and Timothy Wilcox, *The Solitude of Mountains: Constable and the Lake District* (The Wordsworth Trust, exhib. cat., Grasmere 2006)

Judy Crosby Ivy, *Constable and the Critics 1802–1837* (Woodbridge 1991)

C.R. Leslie, *Memoirs of the Life of John Constable Composed Chiefly of his Letters*, ed. Jonathan Mayne (London 1951)

Anne Lyles (ed.), with Sarah Cove, John Gage, Charles Rhyne and Franklin Kelly, *Constable: The Great Landscapes* (Tate Britain, exhib. cat., London 2006)

Edward Morris (ed.), *Constable's Clouds* (Walker Art Gallery, Liverpool, and National Gallery of Scotland, Edinburgh, exhib. cat., 2000)

Leslie Parris and Conal Shields (eds), *John Constable: Further Documents and Correspondence*, part 1 (London and Ipswich 1975)

Graham Reynolds, *Constable: The Natural Painter* (London 1965)

Graham Reynolds, *The Later Paintings and Drawings of John Constable*, 2 vols (New Haven and London 1984), nos 17.1–37.7

Graham Reynolds, *The Early Paintings and Drawings of John Constable*, 2 vols (New Haven and London 1996), nos 90.1–16.111 and Additions 17.29A–36.36

John E. Thornes, *Constable's Skies* (Birmingham 1999)

John E. Thornes, 'A Reassessment of the Solar Geometry of Constable's Salisbury Rainbow', in Amy Concannon (ed.), *In Focus: Salisbury Cathedral from the Meadows exhibited 1831 by John Constable* (Tate Research Publication, London 2017); http://www.tate.org.uk/research/publications/in-focus/salisbury-cathedral-constable/reassessing-the-rainbow, accessed 29 September 2017

Iris Wien, '"[T]he Chiaroscuro does Really Exist in Nature": John Constable's *English Landscape Scenery* and contemporary theories of colour, light and atmosphere', in Magdalena Bushart and Gregor Wedekind (eds), *Die Farbe Grau* (Berlin and Boston 2016), pp. 155–75 (169–74).

Timothy Wilcox, *Constable and Salisbury: The Soul of Landscape* (Salisbury and South Wiltshire Museum, exhib. cat., London 2011)

Andrew Wilton, *Constable's 'English Landscape Scenery'* (British Museum, London 1979)

## Acknowledgments

This publication is profoundly indebted to the fundamental studies of Kurt Badt, R.B. Beckett, Ian Fleming-Williams, John Gage, Leslie Parris and Graham Reynolds. I have also benefited from the advice and insights of Stephen Calloway, Jonathan Clarkson, Amy Concannon, Katherine Coombs, Nicola Costaras, Sarah Cove, David Franklin, Richard Humphreys, Elizabeth James, Anne Lyles, Katharine Martin, Susan Owens, Clare Richardson, Michael Rosenthal, Conal Shields, MaryAnne Stevens, David Thomson, Ian Warrell, Iris Wien, Reinhild Weiss and Timothy Wilcox. I am especially grateful to Professor John E. Thornes for casting his expert meteorologist's eye over my text and making numerous helpful suggestions.

It gives considerable pleasure to record that in July 2017, while this book was being written, Mr Tom Rooth gave the Victoria and Albert Museum the original letters of Archdeacon John Fisher to John Constable, together with additional Fisher family correspondence and the Archdeacon's own copy after a Constable drawing of 1814. Including some of the most pertinent and revealing contemporary comments on Constable's life and work, Fisher's letters had been published by R.B. Beckett in his sixth volume of Constable's correspondence in 1968, and were subsequently acquired by the distinguished Constable scholar Ian Fleming-Williams, from whom they passed to his grandson Mr Rooth. Thanks to his generous gift, these fascinating letters, quoted at some length in the present work, will be available for study in the National Art Library.

For their work on the book I am much indebted to Coralie Hepburn, Kathryn Johnson, Hannah Newell, Tom Windross and Emma Woodiwiss at the V&A and to Susannah Lawson and Julian Honer at Thames & Hudson. Research for this publication was carried out with the resources of the Word & Image Department at the V&A. This book is dedicated to two former colleagues who set me on the path to Constable; Timothy Stevens and the late Edward Morris.

ME

## Author's Biography

Mark Evans is Head of Paintings at the Victoria and Albert Museum, London. He has written extensively on the history of painting from the Renaissance to the twentieth century. His studies of the work of John Constable include essays in *The Burlington Magazine, Kyoto Studies in Art History* and *Constable: Impressions of Land, Sea and Sky* (2006), and two books on the artist: *John Constable: Oil Sketches from the Victoria and Albert Museum* (2011) and *John Constable: The Making of a Master* (2014).

*For Timothy Stevens and*
*in memory of Edward Morris*

*Cover image:* Detail from *Study of Cirrus Clouds, c.*1821/2 (p. 76)
*Opposite title page:* Detail from *Hampstead Heath,*
*Looking towards Harrow, at Sunset,* 1821 (p. 63)
*Opposite contents page:* Detail from *Full-scale Study*
*for 'The Leaping Horse',* 1824–5 (p. 106)

First published in the United Kingdom in 2018
by Thames & Hudson in association with the
Victoria and Albert Museum.

*Constable's Skies: Paintings and Sketches by John Constable*
© 2018 Victoria and Albert Museum/Thames & Hudson

Text and V&A photographs © 2018 Victoria and Albert Museum
Design © 2018 Thames & Hudson

British Library Cataloguing-in-Publication Data
A catalogue record for this book is available from the British Library

ISBN 978-0-500-48032-8
Printed and bound in China by C&C Offset Printing Co. Ltd

To find out about all our publications, please visit
**www.thamesandhudson.com**. There you can subscribe to
our e-newsletter, browse or download our current catalogue,
and buy any titles that are in print.

**V&A Publishing**
Supporting the world's leading
museum of art and design,
the Victoria and Albert
Museum, London